REMEMBERING LYNCHBURG AND CENTRAL VIRGINIA

Remembering Lynchburg and Central Virginia

Articles from the *News & Advance*

Darrell Laurant

Published by The History Press
Charleston, SC 29403
www.historypress.net

Copyright © 2005 by Darrell Laurant
All rights reserved

Front cover image courtesy of Nancy Marion and the Jones Memorial Library.

First published 2005
Manufactured in the United States

ISBN 978.1.59629.082.2

Library of Congress Cataloging-in-Publication Data

Laurant, Darrell.
Remembering the Old Dominion : writings of Lynchburg and central Virginia
/ Darrell Laurant.
p. cm.
ISBN 978-1-59629-082-2 (alk. paper)
1. Lynchburg (Va.)--History--Anecdotes. 2. Lynchburg
(Va.)--Biography--Anecdotes. 3. Lynchburg Region (Va.)--History--Anecdotes.
4. Virginia--History--Anecdotes. I. Title.
F234.L9L38 2005
975.5'671--dc22
2005018357

Notice: The information in this book is true and complete to the best of our knowledge. It is offered without guarantee on the part of the author or The History Press. The author and The History Press disclaim all liability in connection with the use of this book.

All rights reserved. No part of this book may be reproduced or transmitted in any form whatsoever without prior written permission from the publisher except in the case of brief quotations embodied in critical articles and reviews.

Contents

Introduction	7
The bateau man's ghost speaks	9
A day on the river	13
Happy Father's Day, John Lynch	17
Patrick Henry never gave up	21
Rediscovering Mr. Jefferson	23
The Battle of Lynchburg	25
Surrendering all over again	29
Carter Glass and the Federal Reserve	31
The Last Man	35
The "other" Glass	37
Squeek Burnett, barnstormer	41
The D-Day Memorial	45
Reflections on a Saturday hero	49
Watkins Abbitt Sr.	51
Pierce Street, the good times	53
The lunch counter sit-ins	57
E.C. Glass integrates	61
The Nelson County flood	63
Two wars, two stones	67
Earl Hamner	71
The Misses Ward	75
Liberty University	79
The Haysom murders	83
So long, Moral Majority	87
Monacan Homecoming	91
About the Author	93

Introduction

I had no idea.

When I took a job with the *Lynchburg Daily Advance* in 1977, it was as a sportswriter. I knew that Lynchburg had a minor league baseball team, several small colleges, and that it was close to the University of Virginia and Virginia Tech. But, I remained ignorant of Lynchburg's remarkable history, its vast heritage beyond the playing fields.

It wasn't until I moved from sportswriting to column writing in 1981 that it all began seeping in. That's when I learned that Thomas Jefferson spent a lot of time just outside of Lynchburg, in an odd, octagonal Bedford County house he called Poplar Forest. Patrick Henry lived and died in neighboring Campbell County and the founder of the Federal Reserve system had once edited my newspaper.

I began hearing about events at Appomattox in 1865, the catastrophic Nelson County flood of 1969 and how Lynchburg was a hospital town during the Civil War. At some point, I found out that Bedford had lost twenty-three of its sons in the D-Day invasion, which is the highest per capita death toll of any United States community.

I also came to realize that the James River, the boundary between Lynchburg and Amherst County, was America's first traveled river. The Jamestown settlers first used it to venture cautiously into the American interior.

John Wilkes Booth spent a summer in Lynchburg, acting in summer stock theater and hustling the unwary on a pool table in the basement of his hotel. The Warner brothers of movie fame lived here for a time, and so did Frank

James, Jesse's brother. A mob once stormed onto a train stopped at the downtown station and tried to lynch one of its passengers—Vice President Andrew Johnson—before Johnson warded them off with his pistol.

More recently, the Reverend Jerry Falwell has brought international attention to his hometown, and people like George Bush (the elder), Ronald Reagan, Ted Kennedy and the Reverend Jesse Jackson have come to town to meet him.

I could go on, but I won't. This is just a sampling of Lynchburg's past, a mere tasting, and I tried to find examples from twenty-five years of column writing that would hit the historical highlights.

My personal epiphany into the richness of my adopted community's past came several years ago when I stumbled across a copy of a letter Thomas Jefferson had written to a friend in 1815. Jefferson was forced to interrupt his train of thought, he told the friend, because some strangers had ridden up to Poplar Forest to see him. He grumbled a bit at this invasion of his privacy, but the tone changed when he resumed writing.

"The visitors were Andrew Jackson and his entourage," he reported.

Now, that's history.

The bateau man's ghost speaks

It's getting to be fun again, hauntin' this river. Yes, Lord.
I mean, you can't rightly haunt a place where there's no folks. And there hadn't been anybody on the James for a long, long time.

But that didn't keep folks from thinking that they owned it. Slap a few bridges down, throw up a few dams, and figure they had themselves a lap dog. Most of them didn't even look down when they drove across it.

I always used to laugh whenever the river flooded. Lord, I'd laugh. Like the James was supposed to mind these people somehow, stay out of their factories just because they built them down there. "Get out of my mill, river!" Hah. Folks would get mad at the river, call it all kinds of names in their newspaper stories and on television.

The river's like a cup. When it fills up and you keep pourin' water in it, the water's gotta go someplace. Ain't the river's fault, any more than it's the cup's fault.

Anyway, I was left alone for what seemed like forever. Towns like Howardsville and Wingina just dried up and blew off somewhere. People always talking 'bout jobs. Ain't no jobs in Howardsville, gotta go somewhere else. Too bad.

So there was nothing human anymore, just the wind through the pine trees, and water lapping up against the rocks like a wet tongue. Then, a couple of years ago, this fellow Joe Ayers built a boat like the ones I worked on. Well, not exactly like that, but pretty close. And down the river he went, all the way to Richmond.

He didn't have no cargo, though, and I wondered what was the point. Just to do it, I reckon.

But I started laughing when a bunch of other folks got together and organized a bateau race. Them two words make me laugh all by themselves when you put them together—"bateau" and "race."

Let me tell you somethin' about when I was on the river.

I was a slave then. Bein' a slave wasn't what you did, it was what you were. Didn't have no forty-hour week, vacation pay, or retirement benefits. No union. "The Man" breathing on your neck all the time—pull that tobacco, pick that cotton. Go back to a little bitty cabin in the woods with fifteen kids and a dozen dogs and all that noise, everybody fussin' all the time.

So the thing to do was work the bateau. I mean, that was the thing. We'd load a couple of hogsheads of tobacco on the boat, push off, and we'd have a week or so to get down to Richmond, maybe longer.

A bateau race? The faster we went, the faster we'd have to get back to that overseer and that little bitty cabin in the woods. Out on the river, we'd be out in the sunshine all day, pull in at night, sit around a fire and play music. Maybe drink a little corn liquor, just enough to take the chill off.

Why would we want to race down to Richmond? That'd be crazy.

Folks today turn everything into craziness. That first year, they showed up with all them oars—looked like a bunch of crawdads scootin' on downstream. All trying to get there first. If we'd have tried to go that fast, they'd have been picking tobacco out of the river from Balcony Falls to Hopewell.

They say the river'll hurt you, but the river's fine. It's all them rocks in the river that hurt you. Take the rocks out, it'd be just like a bathtub. But they're still in there, maybe even some of the same ones we had to work around.

Ol' Joe Ayers didn't care, of course. He was out there with his poles just taking his time. The man had the right idea.

Last year was a little better. Some folks raced, some didn't.

It's funny, though, we had a crew of three. Some of these boats had twenty. Seems like all those folks would just get in each others' way.

And now we got this business about who sells what T-shirts in what place. T-shirts? When we went down the river, we didn't even wear shirts. We just stripped down because you'd keep getting wet.

'Course, it wasn't about the shirts at all. It was the money, and who got it. So they jawed at each other for awhile, held press conferences (whatever they are), and called each other names. Then they sat down

and decided what they should have decided in the first place. Who cares? The river don't care.

Like I said, it's fun to watch people squabblin'. I don't mind. I like the excitement.

But if this is supposed to be so authentic and all, recreatin' them wonderful olden times, you don't go fightin' over T-shirts. You don't go barreling down the river like you're going to a fire. You take it slow. You feel the river, let it work on you, relax you.

I wish I could float all of you down to Richmond, just once, so you'd see how it's done. And you'd see how silly you are.

Originally published April 18, 1988.

A day on the river

They say time stands still when you're on the river. Ryland Hunt proved that on Monday.

Whenever one of his fellow crew members on the good bateau *Anthony Rucker* would ask the time, Hunt always replied, "It's five after six." That's when his watch had stopped during Sunday's grueling stretch from Stapleton to Bent Creek.

That second day of the James River Bateau Festival was a rock-strewn nightmare that left most participants suffering from bateau fatigue. Several crews showed up at Bent Creek with bent boats. I'm very glad I missed it.

By contrast, Monday's stretch of the James from Bent Creek to Wingina was almost idyllic. In a way, Hunt's stalled timepiece provided a metaphor for the whole day. Nobody knew what time it was, and nobody really cared.

I covered the first two bateau festivals in 1986 and 1987, but only from the shore. Somehow, I never found the time to spend an entire day on the river.

This year, though, one of the flat-bottomed craft was captained by Bob Wimer, our editorial page editor, and I couldn't resist begging a ride.

That's how I found myself careening down a series of lost backroads early Monday morning wearing a cannibalized white shirt with the collar and sleeves cut off, a pair of khaki polyester pants rolled up to the knee, and my son Jeremy's Puma sneakers.

Jeremy, another Monday crew member, was dressed in similar fashion. We had been told to look authentic and this was the best we could do. If

you used your imagination, Jeremy did bear a certain resemblance to Huck Finn. I looked more like a traveling salesman who had barely escaped from a mountain lion.

Ours was definitely a motley crew. Besides Bob, Jeremy and me, it included a former Longwood College wrestler from Venezuela, a Presbyterian minister, a highway engineer, a couple of teenagers, Ryland Hunt (a friend of Bob's) and *News & Daily Advance* advertising director Ed Crickmer. Overseeing this collection of greenhorns was Charlie Seawell, the boat builder and helmsman.

For awhile, it was a little scary. The poles used to propel bateaux are between fifteen and twenty feet long. On the *Rucker*, they were made of pine with weighted tips—lethal weapons in the hands of rookies.

Ideally, you plant that weighted tip in the river bottom, sling the pole over your shoulder and trudge the length of a raised walkway. The pole remains stationary and the boat moves. Then you return to the other end of the boat and repeat the process.

The first problem you discover is that the tip of the pole isn't easy to plant. Rocks shift, sand slides, and the motion of the bateau makes the bottom a moving target. Or you might hit a deep hole and watch the entire pole disappear into the river.

With two polers on each side, I sometimes felt like Little John dueling with Robin Hood. We would draw back our cumbersome staffs for action and feel them tangle with the poles of our fellow crew members. Crack! Ouch!

"Be sure and respect the other person's airspace," Seawell kept telling us.

God bless Charlie Seawell. The first thing he did was take black tape and mark each side of the boat—"P" for port, "S" for starboard. He tried to show us how to pole and provided crucial instructions all the way down the river. "OK, I need two strong poles on the port. Plant 'em wide!"

Meanwhile, either Wimer or Hunt stood on the bow and looked for rocks. The ones that lurked just below the surface were called "sleepers." The bow lookout would point in the direction of trouble, and Seawell would steer us around it.

Hunt and the Venezuelan wrestler, Jesus ("Call me Zeus") Strauss, were very large men, and their poling moved the boat ahead very emphatically. The rest of us gradually got the knack (I, perhaps, last of all).

But in the end, the boat did most of the work.

"She'll float on a wet washcloth," Seawell said proudly.

He may have been right. A shade under forty-seven feet, with an amazingly shallow draught, the *Rucker* glided comfortably over rocks that seemed ready to rise up and devour us. Except in rapids, it rode the river with hardly any side-to-side motion. Even a subtle movement of the rear sweep was enough to change direction.

We were a Class II (non-racing) boat, which meant that we could surrender to the siren call of the Appomattox bateau and join them in a midday swim. We could dodge water balloons from the J.R. Mudcat, and fourteen-year-old Omar Ott could catch seven fish en route.

I was sunburned and sore by the end of the day, but very sorry to see the highway overpass that marked the Wingina camp.

"It seems like we just started," I said to Ryland Hunt. "What time is it, anyway?"

"Five after six," he said.

Originally published June 15, 1988.

Happy Father's Day, John Lynch

You can't take him out to dinner today, send him off to play golf or even give him a card.

That's because he's dead—and has been, since long before Hallmark was founded and the nine-iron was invented.

Still, this seemed to me an appropriate year to pay a Father's Day tribute to Lynchburg's dad, the very late John Lynch.

I've known about Lynch for a long time because I was here during Lynchburg's Bicentennial. I even dressed in a John Lynch costume one Halloween. And every few years around March 17, I issue a strong (and inevitably ignored) protest over the fact that the city doesn't have a St. Patrick's Day parade, even though our founder was but one generation removed from the Auld Sod.

It wasn't until last year when I was doing research for a Lynchburg history that I realized the extent to which the "Lynch" belongs in "Lynchburg."

John Lynch wasn't just one of the influential early leaders of the town—he *was* the town. In his humble, Quaker way, this quiet man with the broad-brimmed hat became to our city what Walt Disney was to Disneyland.

There aren't many quotes from Lynch lying around, and no photographs. All we have is second-hand information, always well-seasoned with respect.

Still, you have to admire the man because John Lynch didn't have it easy. His father died when he was thirteen, and his mother helped found the local Quaker Meeting House. In other words, his teenaged years were probably spent praying and doing chores. If there had been a mall in those days, John wouldn't have been able to hang out there.

His brother Charles got a little out of hand, for a Quaker, joining the Continental army on the eve of the American Revolution. Given the Friends' stand on warfare, that was akin to a modern-day Muslim taking a job as Salman Rushdie's personal secretary.

So Charles became an ex-Quaker, but John quietly took care of business, operating a ferry at the foot of present-day Ninth Street.

If you think Lynchburg is isolated now, you should have been there in 1786. We complain about fighting rush hour traffic in Madison Heights. Back when Lynch founded Lynchburg, traveling to Charlottesville meant fighting Indians and wild animals.

History does not reveal that John Lynch had any grandiose plans for the city he founded. He had his ferry house alongside the James and a couple of tobacco warehouses. Apparently he thought it might be nice if the people who began milling around this riverside crossroads had someplace to live.

But he didn't want them to get wet, so he started laying out lots above what is now Commerce Street. He hired surveyor Richard Stith to divide forty-five steep and slanted acres into equal half-acre lots. Then he offered them to anyone who would agree to build a house sixteen feet square, with a stone chimney, within three years.

All of you dads can guess what happened next. Residents of the new town grabbed up the half-acre lots, then procrastinated. As S. Allen Chambers wrote in his "Architectural History of Lynchburg":

"In 1791, the lethargic Lynchburgers sent to the General Assembly the first of several petitions requesting an extension of time in which to build. This request was approved and followed in due course by yet another in 1793. In 1798, a petition seeking a five-year extension was sought and approved. In 1801 and 1804, further allowances were authorized."

The General Assembly, in this case, was playing Mom to John Lynch's Dad.

"Do we have to build a house this year, Mom? Can we wait? Pu-leeze?"

And then, after everyone was finally settled, they came to Lynch and said, "It's hard to get around with all these ravines and creeks in the middle of town."

So John Lynch built a few bridges and filled in a few ditches.

Then they wanted drinking water, so Lynch laid wooden pipes from springs just south of Court Street. They started dying, so Lynch provided land for a cemetery. They became disorganized, so he helped start a government.

For the last fifty years of his life, John Lynch suffered from what his obituary writers described as "a pulmonary complaint that rendered him extremely weak and feeble in body."

Today, he probably would have checked into Lynchburg General for the necessary surgery. Back in the medical dark ages, he just lived—and died—with it.

John Lynch's grave is next to Quaker Memorial Presbyterian Church, and you can visit it any time. If you do, tell him that his rag-tag little town was recently named the second-best place in the South to live by *Money* magazine. He'd probably appreciate that.

Originally published June 21, 1998.

Patrick Henry never gave up

By all the standards of the day, the fellow was a loser. His schooling was minimal, consisting primarily of Latin grammar and the Roman classics—hardly relevant preparation for life on the frontier. Married just after his eighteenth birthday (despite the considerable misgivings of his in-laws), he received a dowry of six slaves and three hundred sandy acres far from any river transportation.

It would have taken a farming genius to gouge a living from such a place, and the young man was clearly overmatched. All that he and his delicate blonde wife Sara seemed able to produce were children—six of them, in rapid succession. Gradually, the slaves exhausted themselves in daily combat with the barren soil while their master read his Latin. Debts mounted, and it was almost a blessing when a flash fire put the plantation out of its misery.

Homeless at age twenty-one, the young man tried to open a crossroads store. It failed, largely because he couldn't bring himself to collect the outstanding debts of his neighbors. He was a pushover for a hard luck story.

And soon, he had stories of his own to tell. Incredibly, things got worse. His wife was nagged by severe depression, foreshadowing a breakdown that would force Henry to keep her in the basement. Fitful children squalled inside their rented house, and the hard fists of rural creditors hammered on the front door.

Eventually, the young man found himself working in a tavern, tending bar in return for his lodging. He became something of a local character, waiting on tables in his bare feet and strumming the guitar for any customer who fancied the rhythmic chords of an old English ballad.

"But Lord," folks said, "how that fellow could talk." Politics, religion, philosophy, it didn't matter. Like any good bartender, he knew how to stoke a heated discussion, then prod its embers into flame again when the conversation lagged.

In the end, that gift saved him. One day in 1760, John Randolph found a bedraggled apparition standing before him, asking for permission to practice law.

"By what chain of reason he decided to enter the legal profession after failing in a number of other presumably less-demanding careers, and how he managed to prepare himself on such short notice for that profession are questions that must remain unanswered." Historian Richard R. Beeman wrote that nearly two hundred years later. By then, this talkative young man—this Patrick Henry—had become an American icon.

"He really wasn't a political person," said Red Hill Shrine director Patrick Daily, one of the current custodians of the Henry legend. "That's one of the things that surprised me about him."

Political? No. Contentious? Most definitely.

"The Virginians needed and found their own breast-beater," Alistair Cooke wrote of Henry. "Jefferson was not the type. A scholar, a rather wispy redhead and a meditative man, he detested what he called 'the morbid rage of debate.' But there was another man who lived by it; Patrick Henry, half-Scotch, half-Welsh (a formidable merger in itself), a people's lawyer with a smoldering eye, a querulous voice, and a marvelous gift of the gab."

"I know not what course others may take," Henry thundered in 1775, "but as for me, give me liberty or give me death!"

Later, he became governor of Virginia. George Washington, mending political fences after the Revolution, once offered to make him Secretary of State. Henry refused. Chief Justice, then? No.

While Henry loved the verbal jousting of the country courtroom, he couldn't adjust to the compromise and confusion that was national politics. So he continued riding the "circuit," moving to Red Hill near Brookneal in Campbell County. Five years later, as a Lynchburg physician named George Cabell sat nearby, Henry died of an intestinal disorder.

Even today, Red Hill is not an easy place to find—no interstate exit, no shuttle bus, just an unpaved road past two miles of small farms. At the end of that road, today's Fourth of July dignitaries and tourists will find Henry's reconstructed home, his law office, and his grave.

If he were alive, Henry would have told them to dress casually. For it was he, perhaps more than any of his contemporaries, who won the common people to the side of the American Revolution. Because he had failed, they trusted him.

They said all the man could do was talk. But that turned out to be enough.

Originally published July 4, 1983.

Rediscovering Mr. Jefferson

Aside from his being dead, this is one of the best years ever for Thomas Jefferson.

On January 17, President-elect Bill Clinton—William *Jefferson* Clinton, to be exact—will visit Monticello before busing up U.S. 29 to Washington. Throughout the year, Jeffersonian artifacts from around the world will be shipped back to Charlottesville in honor of Jefferson's 250th birthday. A movie is also in the works.

Central Virginia can bask in some of that reflected glory. After all, Jefferson not only used Poplar Forest in Bedford County as his rural retreat, but he occasionally helped Lynchburg with federal government problems and once called it "The most interesting spot in the state."

But as Jefferson scholar Merrill Peterson pointed out in a talk at Sweet Briar College the other day, all the Jefferson worshipping will pass. The Tommy-come-latelies will fade from the scene, all the artifacts will be gathered up and returned to their permanent owners, and the average American will remain just as confused about Thomas Jefferson as before.

"I don't get the sense that Bill Clinton has any real depth of knowledge about Jefferson, do you?" Peterson asked after his talk. "I have heard him quote Lincoln, though."

If you attend sessions of the Virginia General Assembly, however, you'll hear Jefferson quoted a lot—by liberal firebrands and conservative curmudgeons alike. Like the Bible, Thomas Jefferson's writings can supply a quote for all occasions.

The parable of the blind men and the elephant could have been written with Jefferson in mind. Some people stumble across Jefferson the Politician, others Jefferson the Philosopher, still others Jefferson the Architect. There was also Jefferson the Farmer, Jefferson the Art Collector, Jefferson the Winegrower, Jefferson the Educator, Jefferson the Paleontologist, and on and on.

In his lecture, Peterson reminded his audience of a quote attributed to John F. Kennedy at a dinner for an assortment of Nobel Prize winners.

"This is the most extraordinary collection of talents ever assembled at the White House," JFK supposedly said, "with the possible exception of when Thomas Jefferson dined alone."

He contributed mightily to the Declaration of Independence and founded the University of Virginia. But Jefferson was equally proud of his work toward an improved plow and a cure for smallpox.

"As he traveled up to Washington to be inaugurated as vice president," Peterson said, "he carried a box of bones on his lap."

The bones were from a dinosaur unearthed somewhere in western Virginia, and Jefferson seemed almost as excited about that find as his new office.

If the man were alive today, he probably wouldn't be a politician at all. He'd be a talk show host.

A product of Kansas, Merrill Peterson came to Jefferson rather late in his academic career.

"He remains, to this day, a controversial figure," Peterson said. "Some consider him a hero of democracy, others an anti-hero. He's never really codified his writings, just let them stand there as an existential record."

A philosophical elephant, forever puzzled over by blind men. Sweet Briar president Barbara Hill remembers impishly introducing herself at a statewide higher education forum as "Barbara Hill of Sweet Briar College, a school not founded by Thomas Jefferson."

There was silence for a moment, she recalled.

"And then somebody spoke up and said, 'But he probably would have founded it, if he'd thought about it.'"

Have a good year, Tom.

Originally published January 8, 1993.

The Battle of Lynchburg

Even though the currents of battle had not swirled around Lynchburg by June of 1864, it was no secret to the Federal commanders that the city was both a rail and a munitions center. Thus, Ulysses S. Grant ordered Gen. David "Black Dave" Hunter—a staunch abolitionist before the war—to march down from West Virginia and wreak whatever havoc he could.

Of course, in that era of slow-moving, land-bound armies, there was no such thing as a surprise attack on a city. It was soon obvious what Hunter was up to when he began marching southeast with eighteen thousand men and eight artillery batteries, and calvary forces commanded by General John McCausland headed out to begin harassing the northern column.

Nevertheless, on June 11, Hunter's troops scored two simultaneous victories more than sixty miles apart. At the same time the main force was capturing Lexington forty-five miles west of Lynchburg, an auxiliary contingent of calvary was destroying the railroad depot at Arrington thirty-five miles to the north.

At that point, according to a number of historians, Hunter began what would become a series of tactical blunders. First, he called back his calvary raiders from Amherst County, allowing the Confederates to quickly repair the rail line. In addition, he dawdled beyond his own deadline to exit Lexington, amusing himself by ordering the burning of both Virginia Military Institute and Washington College, and carting off a statue of George Washington that stood on the VMI parade ground.

This delay bought Lynchburg some badly needed time. No regular troops were stationed there, leaving the "Silver Grays" and a group of convalescing

soldiers under the informal command of generals Daniel Hill, Harry Thompson Hayes and Francis T. Nichols (who had lost a leg and an arm in separate engagements). General James Breckinridge, himself nursing wounds suffered at Cold Harbor, was dispatched to the city to do what he could. Curmudgeonly General Jubal Early was given orders to load troops onto railroad cars and hurry down from Charlottesville.

Early wasn't in such good shape himself, having been shot twice at Williamsburg, and neither was the Orange & Alexandria line, which had been hastily patched together. The rear car of Early's train derailed on a trestle not far from Lynchburg, and several men were killed when they tried to jump clear. Even so, moving at a maximum speed of twelve miles an hour, the reinforcements reached Lynchburg on the afternoon of June 17.

The Union forces were still on the western outskirts of Lynchburg when Early arrived. A morning skirmish had taken place at Samuel Miller's farm a few miles southwest of the city where Federal troops threatened Miller and "liberated" a forty-five-year-old barrel of French brandy. After that, the invaders advanced to the vicinity of the long-abandoned Quaker Meeting House (which now had a tree growing out of its roof) before being met and pushed back by Confederate calvary under General John Imboden.

Any Lynchburgers who might have been struck by the irony of spilling blood on a Quaker site were doubtless too relieved to care. As for gentle city founder John Lynch, he must have rotated in his grave at the sound of Jubal Early, riding wild-eyed through the midst of the chaos, screaming, "No buttermilk rangers after you now, damn you!"

After that first clash had subsided, Hunter established his headquarters at George Christian Hutter's Bedford County home, Sandusky. There, he promptly had a hole cut in the roof to serve as a lookout station.

This undoubtedly did not endear him to the house's owner, but Hunter and Hutter knew each other from the days when the latter served as paymaster for the United States Army in Charleston, South Carolina. Two members of Hunter's staff would later become President of the United States—Rutherford B. Hayes and William McKinley—and both were with him at Sandusky.

Over dinner that night, Hunter boasted to Hutter that he would be dining in Lynchburg the following night. But while his adversary was crowing, Early kept busy.

He ordered new fortifications erected at a spot later known as Fort Early. Next, he commandeered a switch engine and some cars from the

Southside Railroad and kept running them in and out of the depot all night, accompanied by cheers and the sound of a band playing. The idea was to fool Hunter into thinking the city's badly outnumbered defenders were being reinforced.

Evidently, it worked. On the morning on June 19, Early was amazed to find that Hunter's encircling army had vanished. At first, he thought it was a trick. Then, he sent a dispatch to Robert E. Lee declaring "The enemy is retreating in confusion, and if the calvary does its duty, we will destroy him."

With a headstart of several hours, however, Hunter managed to escape. George Christian Hutter was left with a barn full of dead and wounded Union soldiers, a hole in his roof and a porch that had been pulled down by the Federal horses tied to it. Lynchburg was never directly threatened again until the war ended just twenty-five miles to the east at Appomattox.

Years after the war, a Union veteran of Hunter's corps wrote a cathartic letter to the *Lynchburg News*, saying sourly of his former commander, "As a general, he would have made a good private."

From A City Unto Itself, *Media General, 1998.*

Surrendering all over again

Nancy Leonard was actually crying, tiny tears marching across her mascara like Sherman through Georgia.

"I told myself I wasn't going to let it get to me," said Mrs. Leonard, a member of the United Daughters of the Confederacy from Portsmouth, "but I couldn't help it. When they furled that first flag, it was heart-rending. I'm just glad they didn't play "Dixie"—that would have put me under."

I was a little misty-eyed myself, but only from the spring pollen. With relatives on both sides during the Civil War (or the War of the Northern Aggression, depending upon your perspective), I didn't come to Sunday's surrender re-enactment at Appomattox Courthouse National Historic Park as a participant, despite what Appomattox resident Ben Marshall might have thought. He spotted me and said, "You're here to cheer for the bad guys, aren't you?"

No way. If I had, I would have been cheering alone. Only a respectful silence greeted the Northern troops as they took their positions along the dirt road leading to the McLean House, leaving no sound but the scraping of Union boots in the sand and the metallic snap of Union rifles brought to parade rest.

Then the first Confederate unit came shuffling up the road in double-time, a gaunt gray centipede, and applause rippled along the rail fence beside them.

What we had here was a Southern crowd, one that would have appreciated this account of their original surrender: "The field and staff take their positions in the intervals of regiments, generals in the rear of their commands. They fix bayonets, stack arms, then, hesitantly, remove cartridge boxes and lay them down.

"Lastly, reluctantly, with agony of expression, they tenderly fold their flags, battle-worn and torn, blood-stained, heart-holding colors, and lay them down; some frenziedly rushing from the ranks, kneeling over them,

clinging to them, pressing them to their lips with burning tears. And only the Flag of the Union greets the sky."

The maudlin recollection of some self-pitying rebel? No, those words were written by Brigadier General Joshua Chamberlain, the Union officer who presided over the official surrender. Like Nancy Leonard, he let it get to him.

Robert E. Lee, meanwhile, didn't give it a chance. The date was April 12, 1865, and Lee had capitulated to General Ulysses S. Grant three days earlier. What Appomattox remembered Sunday was the formal surrender ceremony, the stacking of arms and folding—forever—of Confederate battle flags.

According to park director Jon Montgomery, it took "from dawn to near dark" for 28,231 Southern soldiers to pass between Union ranks in 1865. Lee stayed in his headquarters tent much of the day, then left for Richmond around mid-afternoon. He simply was unable to watch.

Grant was already on his way back to a hero's welcome in Washington, leaving the moment to the common foot soldiers like Captain Leonard Mundie of the Fifty-fifth Virginia Infantry—Nancy Leonard's great grandfather.

"Knowing he was here made it very moving to me," she said Sunday. "I'm glad I came."

The re-enactment was carried out by more than five hundred members of the Saylor's Creek Committee—the same folks who gave us the 1984 version of the Battle of Saylor's Creek on Saturday afternoon.

"It turned out to be quite a battle," said Tommy Lavelle of Montgomery County. "I was shot three times."

Not surprisingly. At six-foot-six, Lavelle presented an imposing target. Normally a member of the Twenty-fifth Virginia Infantry, he came to Appomattox as part of the Fifth West Virginia.

A Union outfit?

"You get to participate in more battles if you can switch back and forth," Lavelle said.

Then there was Kawanah Snead of Victoria, dressed as a widow in a black hoop skirt. Her husband, she informed me, had been killed at Chancellorsville.

Later, after the ceremony, my wife Gail poked me and said, "Look, that widow seems to be feeling a lot better."

A young woman dressed similarly to Ms. Snead was engaged in animated conversation with a young Confederate soldier. After all, one can't mourn forever.

Originally published April 9, 1984.

Carter Glass and the Federal Reserve

Like all powerful institutions, the Federal Reserve Bank has been blessed and cursed by businessmen, bureaucrats and politicians alike for decades.

And with good reason. One throwaway comment by a Fed chairman can send the Dow soaring or plunging. One decision by the Federal Reserve Board to raise or lower interest rates can affect hundreds of thousands of individual bank accounts and mortgages.

The members of the Fed board are like engineers inside a hydraulic dam, always prepared to push the necessary buttons to maintain an even flow of currency and commerce. Whatever they decide is bound to hurt some Americans even as it helps others.

So one wonders what critics of this system, now a seemingly permanent part of the financial landscape, would think if they knew that one of its chief architects was a man who had quit school at the age of thirteen to become a printer.

Carter Glass, pint-sized and red-haired, lost his mother when he was two and was raised largely by an older sister. His father, Lynchburg Republican publisher Robert Glass, had fought for the Confederacy and later lost an eye in a duel. In 1861, two of his editors engaged in a gunfight on Main Street with two editors from the rival *Lynchburg Virginian*, and one of the *Virginian* editors was killed.

Born into such contentiousness, it was no surprise that Carter grew up quickly as a young man with a mind of his own. By the time he entered his mid-teens, he was already an enterprising reporter, and in 1880, he joined

the staff of the fledgling *Lynchburg News*, which printed its paper on a press once used to make Confederate money. Before long, he had moved into the publisher's office.

In 1902, Glass was elected to the House of Representatives from Virginia's Sixth District and immediately asked to be placed on the Foreign Relations Committee.

"How about Banking and Currency?" asked House Speaker Joe Cannon.

"I have no experience in that field," the new Congressman replied.

"What experience have you had with foreign relations?" Cannon retorted.

To his credit, the Lynchburg freshman buried himself in his assignment. He plowed through every book he could find on the subjects of banking and currency law, met with bankers, and picked the brains of senior committee members. Only once during his first two terms in the House did he stand up to make a speech, and then only to address a proposed tariff bill affecting the newsprint industry.

During committee meetings, however, Glass talked a lot, and it wasn't long before the depth of his research began to show. At the beginning of his third term, he was given the chairmanship of a subcommittee on monetary reform.

Those who knew Glass back in Virginia must have considered it strange that he would lend his support and expertise to something like the Federal Reserve System. Here, after all, was the epitome of government control and centralizations. Glass, who still remembered the Civil War, was a staunch advocate of regionalism and state's rights.

After a widespread financial panic in 1907 exposed flaws in the American currency system, a National Monetary Commission had been framed to ponder solutions. Following a gestation period of four years, this committee produced the Aldrich Plan, named for Rhode Island Senator Nelson Aldrich, the committee chairman.

Aldrich and his cohorts proposed something called the National Reserve Association, a scheme vaguely similar to what the Federal Reserve eventually became. Glass, not convinced, blasted the plan as "an imperialistic scheme to seize the banking business of the U.S."

But despite this rhetoric, he knew that some kind of national bank was bound to emerge from Congress — the United States hadn't had a national bank since Andrew Jackson vetoed the Second Bank of the United States. So he and chief advisor Parker Willis set to work on a counter-measure to the Aldrich proposal.

During November and December in 1912, the two men came up with a variation on the previous theme.

In their version, the currency issued by a central bank would be backed by gold, not just the outstanding collateral held by other institutions. Glass and Willis also envisioned a financial network made up of regional "clearinghouse cooperatives" instead of a central bank.

Intrigued, President-elect Woodrow Wilson invited Glass and Willis up to his home on the day after Christmas to discuss the measure. More than a foot of snow had fallen on the East Coast on Christmas Eve, and the two Virginians only made it to Princeton because the railroad tracks had been cleared by horse-drawn plows.

Wilson was in bed with a bad cold and had cancelled all his other appointments. According to a 1963 article by Gerald Dunne in "Business Horizons," he listened to the presentation and nodded his approval.

"Glass seemed almost heaven-sent for this part," Dunne wrote, "and so did the proposal, whose fresh and novel approach suggested a possibility of flanking the hardened lines of confrontation."

The chief-executitive-to-be did suggest one change. Instead of Glass's concept of a Comptroller of the Currency to oversee the Federal Reserve, Wilson wanted a board.

A struggle still awaited Glass and his supporters, and it wasn't until December of 1913 that the bill passed the Senate and became law. Two days before Christmas, 1913, Wilson signed the Federal Reserve Act at the White House, using four gold pens—one of which he gave to Glass. Maybe it was just a coincidence, but Richmond, Virginia became the smallest city in America with a Federal Reserve branch.

Nevertheless, Glass later said, "Never in that first meeting in Princeton, or any other, did Mr. Wilson express any familiarity about banking techniques."

Originally published December 23, 1999.

The Last Man

In the end, it didn't turn out quite the way Guy Dirom had planned.

When Dirom and twelve fellow World War I soldiers formed their "Last Man Club" in August of 1918, they envisioned a conclusion filled with high ceremony.

The group's final survivor was to uncork a bottle of Cuban rum, propose a toast, and drink with great gusto to the memory of his twelve friends, fellow warriors in the Eightieth Division American Expeditionary Forces.

It was a bond formed in a French cabaret, a brief haven from the nightmare that was the Western Front. A French interpreter bought the rum, 90-proof Negrita, for $2.40 in American money.

Singer Elsie Janis, a popular entertainer of the day, recited a patriotic speech. Within a few hours, German artillery had reduced the Last Man Club to twelve, killing Frank Clemmer of Staunton.

Even with that, however, it took fifty-seven years for the story to end. Last Thursday, retired Lynchburg Foundry president Henry E. McWane died at eighty-nine in Virginia Baptist Hospital. On Friday morning, Dr. George Craddock informed Dirom, also eighty-nine and a patient at Baptist, that he had become the Last Man.

"I just wish I felt a little better," said Dirom as he prepared to taste the long-awaited Negrita in his hospital room on Monday night.

Thirteen plastic champagne glasses were placed on a tray, and John McWane "Mac" Dirom of Richmond, Dirom's nephew, brought out the bottle.

"When it came down to Henry and I, we flipped to see who would keep it [the rum]," Dirom said. "I didn't want to, but I won."

Wrapped in cellophane, its label faded by age, the Negrita released a pungent aroma into the room when Mac Dirom unscrewed the cap. Joanne Hayes, Dirom's daughter, wrinkled her nose.

"I guess it's aged a little bit," someone said.

Mac Dirom filled all thirteen glasses—an integral part of the ceremony—and Hayes slid the tray in front of her father.

"I'll need a straw," the elder Dirom said, his voice barely audible.

His daughter gave him one, and he winced at the first sip.

"No more," he gasped. "I'll tell you, that'll burn you all the way down."

And so it ended—through a straw, without a toast. George Craddock read the names of the other twelve club members, and Mac Dirom carefully emptied the plastic glasses back into a Mason jar.

"It was just a coincidence that this was done on Veterans Day," said Guy Dirom II, another nephew, "but I think it's appropriate."

"They met every year until 1964," Mac Dirom said.

Besides McWane and Dirom, who is hospitalized with a kidney ailment, the club included former Penn State football coach Bob Higgins, Washington & Lee law professor Clovis Moomaw, Virginia railroad attorney Sidney King, Major General Charles Sweeney and Greensburg, Pennsylvania attorney Vince Smith, the man who was originally entrusted with the bottle.

The bottle, now empty, will be kept by Lucille McWane Watson, McWane's sister.

"I think it was important to do this," said Dirom II. "We came to his room Friday night, after he learned about Henry, and he was tossing and turning, obviously not feeling good. We reminded him of the bottle and the ceremony, and he brightened right up."

Until the first sip.

Originally published November 12, 1985.

The "other" Glass

When Edward Christian Glass began teaching Lynchburg's children, he was only a child himself. When he finished, he was an icon. In between lay sixty years of service to the city of his birth.

"What he has done," Glass's brother, Carter Glass, once said, "will be remembered years after what I've done has been forgotten."

Well, maybe—although if you ask most people in Lynchburg today who the sprawling, college-sized E.C. Glass High School on Langhorne Road is named after, they'll probably tell you "E. Carter Glass."

Which would be wrong. Carter Glass was the politician in the family, serving in the House of Representatives and Congress and as Secretary of the Treasury under Woodrow Wilson. Edward Christian Glass and his sister Meta (who became president of Sweet Briar College) were the educators.

In fact, had E.C. Glass been saddled with Carter as a student, he probably would have been forced to apply one of his infamous switches to the future senator more than once. Feisty, hyperactive and eager to get on with his life, Carter was a reluctant student and finally quit school at thirteen.

By contrast, only death made E.C. Glass quit school. Appointed superintendent of the Lynchburg Public Schools at age twenty-seven, he served in that post from 1879 until his passing in 1931. Whatever recognition the city's educational system receives today can be credited, in large part, to Glass's efforts in the early part of the twentieth century.

Better known as "Ned" during his teaching days, the eighteen year old Glass was hired in 1871 by then-superintendent Abraham Biggers as

assistant principal of "School No. 2" on Jackson Street. His salary was seventy-five dollars a month.

Interestingly, E.C. Glass then made it to the House of Representatives before Carter did. After a year at Jackson Street, he moved to Washington and took a job in the House Post Office, then with the Doorkeeper's Department.

Seasoned and broadened by that experience, he returned to Lynchburg in 1878 to face a political mess. A penny-squeezing City Council, faced with overcrowding in the public schools and the obvious need for an expensive building campaign, had simply shut public education down.

A year later, however, that entire council was bounced from office by angry voters, and the schools were re-opened. When Superintendent Biggers died young of tuberculosis, the now-worldy Ned Glass was offered his position.

At the beginning of Glass's tenure, the public school system owned only two pieces of property and educated around five hundred students. When he left the scene during the early years of the Great Depression, there were six thousand-plus children in the city's sixteen white and eight black schools, and the physical plant had expanded dramatically.

"He set a standard for incoming superintendents," said Frances Adams Deyerle, Glass's long-time secretary, in 1981.

And made an impression on generations of students—sometimes, a painful one.

"The bad students were sent down to his office," Deyerle recalled. "He'd give them a second chance, but after that he'd send out for switches. They came from a tree in the backyard behind the building.

"He would take them into the auditorium and close the doors, but we could hear him when he whipped a boy. He never whipped a girl—there was never any reason to."

Glass never particularly enjoyed his role as the heavy, however. His real passion was not punishment but spelling, and his "Glass Speller," published in 1899, was used not only in Lynchburg but statewide. To him, "a word misspelled is another word or no word, and thus unacceptable."

The best way to score points with Superintendent Glass was to correctly spell the word "separate."

"Most students," he often complained, "spell it 'seperate.'"

He was also strict with the teachers. After spending mornings hunched over his battleship-like desk ("It was built for Goliath," a later superintendent, Joe Spagnolo, once marveled), dealing with matters of administration and

correspondence, Glass would walk to his nearby home on Court Street for lunch, then spend the afternoon sitting in a classroom somewhere in his little empire. He wanted to see, firsthand, what his teachers were doing.

"He always pretended to be reading," Frances Deyerle once said, "but the students and the teachers knew better."

Although E.C. Glass spent his entire educational career in Lynchburg, he was like a rock hurled into the middle of the Virginia educational system, sending concentric circles of influence statewide. A charter member of the State Board of Education, he pushed for and then directed a summer program for teachers at the University of Virginia. He even set up an International Teachers' Exchange, inviting Helen Rattray from Scotland to work in Lynchburg.

Closer to home, Glass made the local schools co-educational in the late 1870s and worked for better education for black students. He added music and art to the curriculum and insisted that the new high school, built in 1899, include a science laboratory. A later high school was named after him, in 1920, eleven years before he retired. His name followed the school to Langhorne Road in the 1950s.

While Glass remained close to his more famous sibling, he wasn't afraid to disagree with the family newspaper if an editorial seemed critical of his concept of education.

When E.C. Glass was terminally ill in 1931, State Attorney General John Saunders said, "The greatest man in the South lies dying."

Originally published December 12, 1999.

Squeek Burnett, barnstormer

These days, seventy-nine-year-old Joe Vaughn sells cars for Kenneth Hammersley Lincoln-Mercury.

There was a time, however, when his product was Vincent "Squeek" Burnett—and the selling wasn't always easy.

"We'd show up in some little town with our airplane," Vaughn said of his Depression-era barnstorming trips with Burnett, "and the sight of Squeek would scare people to death. They'd look at him and say, 'I'm not going up with him. He's just a kid.'

"They were right, of course. Squeek was only eighteen the year he got his first commercial license."

"Seventeen," corrected Burnett from the other end of his living room couch. "I lied about my age."

"And he looked about twelve," added Burnett's wife, Evelyn.

To gain the confidence of their public, it became necessary for Vaughn and Burnett to provide a demonstration.

"He'd do a few barrel rolls, some dives, and the customers would realize what a good pilot he was," Vaughn recalled. "Then we couldn't keep them out of the plane."

At first glance, Squeek Burnett no longer looks eighteen, or even fifty. His hair is as white as a cumulus cloud, his blood pressure is at high altitude and climbing, his emphysema is on the warpath. But when you look closer, the old barnstormer still has the sparkling eyes of a teenager.

And the same sense of adventure. So when Vaughn suggested a balloon ride early next week to celebrate his eightieth birthday, the seventy-two-year-old Burnett said, "Count me in."

"It's something I've never done," said Vaughn, "and neither has Squeek."

One of the few things. Given the limitations of space, I won't launch into a detailed description of Squeek Burnett's exploits. He won several national aerobatics titles during the 1930s, pioneered a couple of routines that have become air show staples and advised General Jimmy Doolittle during World War II. Your basic legend stuff.

To me, Burnett's career is best epitomized by a single *LIFE* magazine photograph. The picture, which spread across two pages, showed Squeek's open cockpit plane skimming along upside down, just five feet off the ground, the inverted wheels slicing cleanly through a ribbon stretched between two poles.

Burnett performed that trick all over the country, along with others equally hair-raising.

"It was no big deal," he said. "I always knew what the airplane could do, and I never pushed it beyond those limits."

Apparently, this attitude was catching. When Burnett taught instrument flying to Navy pilots in 1940 and 1941, Evelyn would go along as a "spotter."

"Squeek and the pilot would have their heads under a hood, flying blind," she said, "and they needed me to look out for other aircraft that might be in the area."

Evelyn and Squeek met in Bluefield, West Virginia, forty-seven years ago. Fresh-faced and jockey-sized (5-foot-5, less than 130 pounds), Squeek wasn't the heart-throb type. But Evelyn knew he was a little unusal after he took her up for a ride.

"He told me we were just going to fly around a little bit," she said. "When I got the nerve to open my eyes, I said, 'This doesn't look like Bluefield.' He said, 'It isn't. That's New Bern, North Carolina down there.'"

Evelyn has become the family historian, and is trying to find an author to translate her roomful of letters and clippings and awards into a Squeek book.

"I don't care much about that stuff," Squeek said, "but she likes it."

Burnett's only crash came on a routine takeoff from Falwell Airport in Campbell County in 1970.

"The engine just cut out," he recalled, "and I tore up a lot of squirrels' nests."

It took extensive surgery to save Burnett's right hand.

"I was playing golf at the time," said Vaughn, "and I actually saw the plane go into the trees. Didn't know it was Squeek, though, until a couple of days later."

Vaughn was working for the Lynchburg Flying Service when he and Burnett first crossed paths.

"He was great at stunt flying," Vaughn recalled, "and I was great at selling tickets. We made a great pair."

And Tuesday, they'll be teaming up again.

"I've got a plan," Burnett said. "once the balloon goes up, I'm going to throw Joe off and see if he bounces."

"I'd just like to see you try," his old friend growled.

Originally published August 16, 1985.

The D-Day Memorial

Bob Slaughter has seen *Saving Private Ryan* five times, enough to have developed a grudging admiration for Steven Spielberg's art. Yet no matter how many times he watches that film, he knows it will never compare in drama and horror to the D-Day movie in his own memory.

"There are a few little gaps in the day," said the former infantryman of his experiences, "but for the most part, I remember every bit of it."

And over the past decade, those memories have been goading Slaughter and a widening circle of comrades as they struggle to establish a different sort of beachhead, a national memorial for the D-Day dead in Bedford.

This mission is one of construction rather than destruction, and the enemy in 1999 is far more relentless than even Nazi Germany—time. At the memorial's groundbreaking on Veterans Day, 1997, Virginia Senator John Warner called it "The Last Campaign."

"We're losing D-Day veterans every day," Slaughter said earlier this year. "What drives me is getting this finished while some of us are still around to visit it."

To Bill McIntosh, director of a proposed Education Center at the National D-Day Memorial, the 1944 assault on the Normandy beaches may have been the "watershed event" of the twentieth century.

"If you look at what followed, and what could have followed had things gone differently," said the former West Point instructor, "you can certainly make that case."

In Bedford, D-Day unfolded not as a violent, day-long spasm, but a gradual bleeding stretched out over two weeks. On the Sunday after the

massive Allied invasion of France, telegraph operator Elizabeth Teass settled into her Western Union cubicle at the rear of Green's Drug Store and received the following message: "Good morning. We have casualties."

The news leaked out slowly, cruelly. On the same Sunday, a telegraph runner came to Lucille Boggess's home in Bedford with news that her older brother, Buford Hoback, had died on Omaha Beach. The next day, another telegram informed the family that her younger brother, Raymond, was missing. His Bible was later dug out of the Normandy sand, but Raymond Hoback was never found.

In all, little Bedford (population 3,200 in 1944) lost nineteen of its sons on D-Day, four more in the hedgerow-to-hedgerow fighting that followed—the highest per capita loss on that day of any community in the United States. It was a sacrifice that stamped and defined Bedford, a memory so profound that President Clinton mentioned the town in his fiftieth anniversary speech at Coleville-sur-Mer, France, in 1994. For decades, a two-ton stone shipped over from Normandy has been sitting in front of the Bedford County Courthouse with twenty-three names inscribed on it.

So to longtime mayor Mike Shelton, it only seemed fitting that his community was chosen as the site for the national memorial, an ambitious and majestic project now slowly emerging from a broad hillside not far from the Elk's National Home.

"We went after it very aggressively," Shelton said. "Lucille [Boggess, then the chairman of the Bedford County Board of Supervisors] and I got our hands on their criteria, and we made sure we answered every possible objection they might have."

Companies A, B, C and D of the 116th Division and 29th Infantry were former National Guard units stocked largely with troops from Bedford, Lynchburg and Roanoke. As Slaughter recalled, "It was the luck of the draw, in many cases. Company A came ashore right in front of a huge pillbox, and they didn't stand a chance. I was a little ways down the beach, and I could hear the burp guns just ripping them apart."

The luck of the draw. Just before they boarded their respective landing crafts that gray morning, Ray Stevens of Bedford walked over to his twin brother, Roy.

"He put his hand out for me to shake it," Roy recalled more than fifty years later. "I said, 'No, I'll shake your hand at the Vierville-Sur-Mer crossroads.' Since then, I wish maybe I would have shook his hand."

Roy Stevens's boat foundered in the surf and sank. He was rescued by another vessel and never made it to the beach. Ray Stevens did make it, and was cut down.

As Richard Burrow, director of the D-Day Memorial Foundation, often points out in his talks to civic groups and veterans organizations, this was the first live action the National Guardsmen in Companies A, B and C had faced. They were hurled into the long conflict at its pivotal point, and the importance of their mission made it equally important to the other side.

"We trained for months in England," recalled Slaughter, a Roanoke resident whose idea for a monument in that city eventually turned into the Bedford memorial. "We'd practice climbing cargo nets. We'd ride out into the channel and head for the beach under simulated fire. We thought all this was really getting us prepared, but it wasn't."

"I got out of the boat that morning and the guy next to me fell dead. When you have people you know—your friends—going down with their arms and legs shot off, screaming, nothing prepares you for that."

Instead of the green and incompetent Eastern European conscripts they'd been told they'd be facing, the invaders stumbled ashore into a withering fire from seasoned German troops.

"I felt like a small morsel on a big, sandy platter," Slaughter said. "You just did what you had to to survive."

It wasn't until forty-three years later that Slaughter, then a pressroom employee at the *Roanoke Times & World News*, began discussing the possibility of a D-Day monument for Bedford's Center in the Square with a co-worker. A committee was formed, and the idea soon grew too big for a niche in Roanoke's downtown area. That's when Mike Shelton, who works at Virginia Western Community College and knew some of the D-Day committee members, weighed in.

Bedford was officially named the memorial site on Veterans Day, 1994.

Originally published December 27, 1999.

Reflections on a Saturday hero

I had decided a long time ago to write about Desmond Doss today. The calendar demanded it.

It was fifty years ago tomorrow—April 29, 1945—that the Lynchburg native committed the first in a series of heroic acts that would ultimately win him a Congressional Medal of Honor.

That day was also a Saturday, a precious foxhole of time into which the devout Seventh Day Adventist and conscientious objector normally retreated for worship and contemplation.

He had fought for those Saturdays on his own private battleground, overcoming disciplinary measures and scowls from his commanding officers and mocking from his fellow soldiers. Eventually, grudgingly, he won their respect—and when he quietly enfolded Saturday around him, they learned to draw back and let him be.

Those who knew Desmond Doss back in Lynchburg might have predicted that he would become a hero. But not on a Saturday.

Doss wouldn't have chosen that day, either, except that this was Okinawa—one of the fiercest bloodlettings in the late stages of World War II—and he was the only medical corpsman left.

"The Japanese made a practice of shooting medics whenever they saw them," Doss said in a telephone conversation from his home in Rising Fawn, Georgia, two years ago. "It was bad for morale."

So Doss came out of his personal foxhole on that Saturday and did his job, no doubt praying that God would forgive him. He found his company, part of the 177th Infantry, pinned down atop a sheer bluff by enemy fire.

The only way to save the wounded was to crawl across the rocks, drag them to the edge of the escarpment, and lower them down.

And that's what Doss did, dragging them with all the strength in his 5-foot-10, 140-pound body, lowering them to safety using a knot he had learned as a Boy Scout. In all, he was credited with saving seventy-five of his fellow soldiers that Saturday.

Nor did it end there. Over the next few days, Doss suffered serious shrapnel wounds in both legs trying to kick a grenade away from his fellow soldiers, then was shot in the left arm — breaking two bones — while carrying a litter.

Doss was in poor health when I spoke with him two years ago, having just survived an automobile accident that killed his wife of forty-eight years. His sister, Audrey Millner of Lynchburg, told me recently that he's largely recovered from that, although he still feels the effects of tuberculosis he contracted during the war.

"He's remarried," Millner said, "and seems to be doing pretty well."

I think we owe Desmond Doss some mention today, especially since we inadvertently killed him off in 1945. Pawing through his file, I found a yellowed two-paragraph correction that read: "Pfc Desmond T. Doss was, through error, listed in the casualty column of the *Daily Advance* yesterday under the heading of 'Army Dead' instead of 'Army Wounded.'"

Moreover, Doss's acts of bravery—while no more courageous, necessarily, than acts performed by men with weapons in their hands—remind us that the "Good War" wasn't just about killing. It was also, in a very real sense, a rescue effort.

And just as the heroism of the rescue crews in Oklahoma City quickly overshadowed the harshness of the act that made their presence necessary, so Desmond Doss made his own statement, in his own way.

On his own day.

Originally published April 28, 1995.

Watkins Abbitt Sr.

The truism "all politics is local" has been credited to former Speaker of the House Tip O'Neill.

But if O'Neill said it, Watkins M. (Wat) Abbitt lived it.

Once, when he was asked the secret of his political longevity (seventeen terms in Congress), Abbitt replied: "Barbecue."

Pressed for an explanation, he drawled: "They have a lot of barbecues in my district, and whenever they have one, I try to show up. If people know you, and they don't know the other fellow, you'll get their vote."

It works that way from student government elections in high school on up to the presidential primaries, and Abbitt knew it.

He also realized the importance of loyalty. He was a staunch foot soldier for Harry Byrd's Democratic "machine" in state politics, then represented the same interests in Washington. When it came to defending the majority views of his constituents in the House of Representatives, he lived by another old political slogan: "Dance with the one that brung you." Or, in Abbitt's case, the ones who sent him.

As a member of the House Agriculture Committee, for example, he fought furiously against the Federal Communications Commission's ban on cigarette advertising on radio and television. Abbitt didn't even smoke, although he occasionally chewed on a cigar, but a lot of folks in his fourth Congressional District (Appomattox, Cumberland, Buckingham and Prince Edward County) grew tobacco.

Wat Abbitt never became an "inside the beltway" sort of guy, returning to Appomattox nearly every Thursday from 1948 to 1972. One of his Virginia colleagues once talked about how the Congressman used his last name (which put him first on the roll call) to good advantage.

"Whenever we took the final vote of the day, Wat would arrange to have his car parked just outside the door with the engine running and fully warmed up. When the name "Abbitt" was called, Wat would answer on his way to the door."

The people in Abbitt's district liked the way he always remained one of them, driving an old pickup truck with fertilizer sacks in the back and going deer hunting with his buddies and never missing the Shad Planking in Wakefield, Virginia, the springtime tribal ritual of the Byrd machine.

Yet Watkins Abbitt didn't spend his whole life in the United States Congress, even though it began to seem that way. For sixteen years prior to winning his first Congressional election, he served as Commonwealth's Attorney of Appomattox County (his brother, George, was a circuit judge during much of the same period). Since rural courthouses were the building blocks of the Byrd Machine, Abbitt was already a loyal Byrd lieutenant when he went to Washington for the first time.

In beating Morton Goode in 1948, in a special election to replace the deceased Representative Patrick Drewry, Abbitt got all but seventeen of the votes cast in Appomattox and Buckingham counties. Later, he faced opposition only twice.

Fidelity to Senator Harry Byrd and to the mostly white voters in his district made Abbitt a symbol of "massive resistance" to school integration in the 1960s. After all, his district included Prince Edward County, the only county in Virginia that closed its schools rather than integrate them.

During one House debate on a pending civil rights bill in 1963, Abbitt stood at his seat and blasted the legislation as "the most iniquitous, dangerous, liberty-destroying proposal that has ever been reported to by Congress by one of the committees since the days of Reconstruction."

When the dust had settled, however, and Abbitt went back to his barbecues and took the pulse of his consitutents, he began to accept that times had changed.

"Wat was a man for all seasons," said Del. Richard Cranwell on Abbitt's death last year. "You'll find that over the past fifteen to twenty years, he did as much for race relations and dialogue with the African-American community as anyone."

In the process, he provided an example to all those in Southside Virginia who bore grudges and stubbornly resisted the inevitable. If Ol' Wat could change his way of thinking, anyone could.

That, as much as anything, may be his legacy.

Originally published December 10, 1999.

Pierce Street, the good times

The two-story house on the corner of 14th and Pierce displays a prominent "No Trespassing" sign.

I found that ironic. During the 1950s and 1960s, when Dr. R. Walter Johnson lived there, the house was a magnet for strangers.

"There was always something going on," said Erdice Creecy, who lives in the place now. "People coming in from all over for tournaments and get-togethers. Those were good times."

When you drive slowly down Pierce Street these days, you can see that the good times have left. Across from the Johnson house is a small grocery and a vacant lot. Several of the nearby houses have turned gray—the color of death—and neglect has begun to dismember some of the others. The "nice" houses that remain on the block are beginning to find themselves outnumbered.

The paint is peeling on Walter Johnson's old two-story, too, but it remains proud, erect and neatly kept. Inside, I found Creecy dressed just as neatly, in a brown suit and white hat.

It had occurred to me, while writing the standard "local reaction" piece on Arthur Ashe's death last month, that I had never seen the clay court where Johnson and his son Bobby taught the skinny youngster from Richmond the rudiments of tennis.

"I'd like to see that court, if I could," I told Creecy over the phone.

"There's really nothing there any more," she replied in gentle protest.

"I'd like to see it anyway," I said.

The "No Trespassing" sign is necessary now. Pierce Street has changed since eight-year-old Arthur Ashe first arrived in 1953.

"It got pretty bad for awhile, with the drugs," Creecy said. "For some reason, the last two years have been better. Quieter. Seems to be a younger crowd doing it now."

Whatever its mood today, however, this block of Pierce Street is thick with history. A block from the Johnson home is the Anne Spencer House—a frequent stop on a cultural underground railroad through the segregated South.

W.E.B. DuBois stopped there to meet the Lynchburg poet. So did Langston Hughes, Thurgood Marshall, George Washington Carver, H.L. Mencken and James Weldon Johnson.

Mencken, the acerbic Baltimore newspaperman, read one of the poems Spencer had scrawled across her kitchen wallpaper and said, "I like it, but I don't like the title."

"Then you can write your own poem," Spencer shot back, "and call it whatever you like."

Now, only the octogenarian Chauncey Spencer (Anne's son) remains to tend the family flame, just as Creecy's presence provides a link between Walter Johnson (for whom she worked for twenty-four years) and an uncertain present.

Arthur Ashe, dead of AIDS, was another link. It would have tortured Johnson, a general practitioner with an office on Fifth Street, to see his protégé succumb to a disease without a cure — just as it would have tormented him to see crack merchants on nearby street corners.

A handsome college football star who became a doctor, Johnson probably would have been welcomed into the rich cream at the top of Lynchburg society, invited to join the local country clubs and steered into a lucrative practice. If he'd been white.

Instead, he served an inner-city community on a dead-end street.

"His friends always called him 'Whirlwind,'" Chauncey Spencer said recently, "because that was his football nickname."

But it was tennis to which Johnson came late in life. A country club sport—a white man's sport.

Maybe that was Walter Johnson's little joke on the society that liked and respected him but wouldn't welcome him on equal terms. He would take African-American youngsters from the inner cities and train them to beat the country club kids at their own game. And beat them politely.

In his autobiography, Arthur Ashe recalled that Johnson always told him to concede close line calls. A black player had to be polite to be invited back, because the whites controlled the courts.

"Young people at that age like to do things to get attention," Erdice Creecy said. "Argue with the officials. Throw rackets. It's natural—but Dr. Johnson's players never did that."

Of course, Johnson also served on the city's multi-racial commission in the 1960s. Recently, Ken West reminisced in his weekly *News & Advance* column about how the doctor had invited him—a white kid—to join his troupe for a summertime tour of junior tournaments.

So perhaps it wasn't entirely racial. Certainly, the adult Arthur Ashe enjoyed the close friendship of people of all races.

As a pre-teen with arms as thin as pipe cleaners, Ashe needed Johnson's defensive, baseline-oriented strategy. Later, as his strength increased, his game became more aggressive.

But the humility remained. During his summers in Lynchburg, Ashe got up at 6:30 in the morning to bang thousands of solitary forehands against a wooden backboard. He made beds, washed dishes, rolled the clay court, weeded Johnson's garden and cleaned the dog house.

"A very nice, polite young man," Erdice Creecy had called him.

As she had warned me, the clay court is gone. In its place is a curious, flat-topped rise next to the old house—a scruffy patch of winter-killed grass bounded by naked metal poles. In front of it is a plaque erected by the Links, Inc., sorority, recalling how Johnson used this spot to train Ashe and Althea Gibson, both of whom later won the U.S. Open and Wimbledon.

It was dripping rain, the street was deserted, and there were a couple of empty beer bottles lying in the short grass of the former court.

In the stillness, I could almost hear Walter Johnson's voice: "Arthur, when you get a chance, please come out here and pick these up."

Originally published on March 5, 1993.

The lunch counter sit-ins

When the barriers between blacks and whites began to be breached during the 1960s, the simplest human acts often wound up as acts of defiance. Ordering food, using a restroom, even walking on a sidewalk could take on profound significance.

For segregation had to be all or nothing. The legal structure of the "separate but equal" South was like a house built of children's blocks—if any part of it was taken away, the whole thing would collapse.

William Patterson knew that when he stood behind the lunch counter of his drugstore on Lynchburg's Main Street on December 14, 1960, and confronted six college students.

One of them was Randolph-Macon Woman's College student Mary Edith Bentley, who recalled years later: "The waitress started pouring coffee, and then she saw the two black students sitting there, and she froze. Everything got real quiet. Then Mr. Patterson came out. He was all red in the face. The blood vessels in his neck were pounding. He started pacing back and forth behind the counter, talking to us."

The winds of change had turned a normally amiable druggist into a Mr. Hyde, Bentley and her five companions into criminals.

Patterson's lunch counter, like all the others in downtown Lynchburg, was segregated. Two of the college students, Barbara Thomas and Kenneth Green of Virginia Seminary, were black.

Ever since a similar "sit-in" had been held in Greensboro a few months earlier, white merchants had dreaded this moment.

There was no violence, however, and not even a threat of violence. Patterson warned the students that they would be arrested if they didn't

leave, and they simply sat there, silently. Lieutenant E.P. Puckett of the Lynchburg Police Department arrived a few minutes later, Bentley (now Mary Abu-Saba) remembered, and told the six, "You can end this right now. Just stand up and walk out."

Mary Edith Bentley was a church organist on Sundays, the daughter of a minister. The idea of breaking the law strained against her upbringing. Nevertheless, she shook her head. A police wagon arrived.

"All six," the *News* reported the next day, "were locked up without supper."

Along with Bentley, Thomas and Green, the defiant half-dozen included Rebecca Owen of R-MWC and two Lynchburg College students, James Hunter and Terrill Brumback.

The next day, four more R-MWC students showed up at Peoples' Drugs along with a black friend, Miriam Gaines of Campbell County High School. Durwood Frye, the Peoples' manager, took a less confrontative approach, simply closing the counter and turning off the outside lights.

"In Greensboro, blacks were doing it," Tom Ledford of the Lynchburg museum once said of the local sit-ins. "In Lynchburg, it was nice white kids. The whole thing went down altogether differently."

It became a local soap opera. On January 5, 1961, a crowd more befitting a notorious murder trial than a simple trespassing case overran Lynchburg Municipal Court, forcing some to stand at the back of the courtroom and others to peer through the windows from outside.

Leonard Holt, the defendants' attorney, was a civil rights warrior who had come up from Norfolk with an agenda. Given the laws of the day, he had no real legal defense, but saw the hearing as a chance to make himself heard on the larger issues.

"He [Holt] spoke often, and in a loud voice," Jim Murdock of *The News* reported.

But to no avail. Indeed, Holt's bombast simply succeeded in making Judge Joseph P. McCarron angry enough to sentence the defendants to thirty days in jail, knowing that most of them would have no trouble paying fines.

The six students appealed, setting up another courtroom circus. Corporation Court Judge Duval Martin announced prior to that February 6 trial date that the courtroom would be segregated. The Reverend John Teeter, the white pastor of a largely black congregation (the Episcopal Church of the Good Shepherd), decided to test the ruling by taking a seat in the "black" section. He was forcibly removed by Lynchburg police officers, and a photograph of the incident went out over the *Associated Press* wire.

Martin, like McCarron, was unmoved by the students' arguments, and upheld the original sentence. In the meantime, college presidents Orville Wake (Lynchburg College) and Bill Quillian (Randolph-Macon Woman's College) had been fielding telephone calls from board members and community supporters urging them to expel the arrestees. Ultimately, though, Hunter and Brumback were placed on probation by LC, while Quillian finally decided that jail time was punishment enough for Bentley and Owen.

Owen, who was Phi Beta Kappa at Randolph-Macon, immediately amused her jailers by requesting a novel by Turgenev, a book on economics and the *New York Times*.

"Most of the reading here doesn't go beyond comic books," one jailer said.

Quillian brought a box of books over himself, and groups of sympathizers gathered beneath the students' cell windows singing hymns.

"It was just unbelievable," Bentley said years later. "It made me feel humble."

The six were finally released from jail a few days early on "good behavior." But the civil rights genie was out of the bottle in Lynchburg, never again to be contained.

Originally published December 17, 1999.

E.C. Glass integrates

Lynda Woodruff still gets emotional when she talks about it. She always will. Each year on January 29, she and Owen Cardwell Jr. still send each other roses.

There is a tendency to think of Woodruff and Cardwell—the first black students to attend previously all-white E.C. Glass High School—as civil rights soldiers, wading bravely ashore onto a cultural beachhead.

But it wasn't like that, Woodruff said earlier this year. It was an ambush.

"We had no idea what it would be like to actually walk into a white school and sit down with a class of white kids."

She was fourteen. Cardwell was thirteen.

"Ignorance was bliss, I think," she said.

Lynchburg News reporter Jim Murdock was there on January 29, 1962, when Woodruff and Cardwell first entered Glass under a court desegregation order. He came back to the office shaking his head.

"It turned out to be a non-story," Murdock said many years later. "The car pulled up with the Cardwell boy and Lynda Woodruff, and they went inside. Some kids stood outside and stared at them. And that was it. The AP was probably hoping for a riot, but they didn't get it."

Little Rock, it was not.

And so the newspaper and TV reporters went away, and the white world of E.C. Glass quietly closed in around Cardwell and Woodruff and swallowed them. Or, perhaps more accurately, tried to spit them out.

Their bad dream had begun at a mass meeting at Diamond Hill Baptist Church.

"The leaders called for volunteers to apply for transfer [from all-black Dunbar to E.C. Glass]," said Woodruff, now a college administrator in Georgia. "There must have been a dozen kids who stood up—but when it came down to who actually came forward and had their parents sign papers,

there were only four of us. Owen and I were picked to start first, and our IQ's were published in the newspaper."

It was mid-semester. Even for white students, entering this new school after all its cliques had been formed would have been traumatic. Most teenagers want desperately to be popular, and if that fails, they at least don't want to be different. Woodruff and Cardwell were doomed on both counts.

"What devastated us was being stripped of all the things we'd been identified with," Woodruff said. "I had been a majorette at Dunbar, and involved with a lot of clubs. That didn't transfer. Owen had played basketball. That didn't transfer."

On the academic front, it was even worse.

"When we left Dunbar, we were on Chapter Eleven in our Latin books," said Woodruff, the daughter of Georgia and Ed Barksdale (the latter a current City Council member). "When we got to Glass, we sat down the first day and the teacher said, 'Open your books to Chapter Thirty-Two.' I remember we looked across the room at each other. Owen was being brave. I started to cry."

The two were even snubbed by many of their old friends at Dunbar, Woodruff recalled, "because we had gone on record as saying Dunbar was inferior."

The next semester, Cecilia Jackson and Brenda Hughes became the third and fourth black students at Glass. Their predecessors warned them about the silence they would face in the halls, the bus drivers who might drive past them without picking them up, the teachers (not all, but a few) who seemed determined to help them fail.

"Lunch was a daily ritual," said Hughes, now Brenda Andrews and editor of the *New Journal & Guide* newspaper in Norfolk. "Once we got through the line, we had to find a place to sit. Sometimes, there was an empty table. If there wasn't, any time we sat down, everybody would get up and run to another table, as if we were polluting the air they were breathing."

More black students came to Glass in subsequent years, and Dunbar High School became a middle school. Integration in Lynchburg's elementary schools proceeded at the same glacial pace.

"There was no excuse for the way it was done," said Diamond Hill Baptist Church minister and community activist Haywood Robinson. "They just threw those young people to the wolves."

"I thought we were participating in integration," said Owen Cardwell, "when it was assimilation. We didn't come to the table as equals, but got assimilated into the majority culture.

"There are times when I wonder if it was worth it."

Originally published December 19, 1999.

The Nelson County flood

Floodwaters eventually recede. Flood memories don't.

"I remember when we dedicated the memorial at Wood's Mill on the twenty-fifth anniversary of the [Nelson County] flood," Warren Raines was saying Thursday night in the back room of his electronics shop and video store on Virginia 151. "As we were driving away, I looked over at my wife and said, 'Well, this is closure. Nobody is going to care about what happened here after this. It's old news.'"

He was wrong.

"This year, the thirtieth anniversary, there's been even more attention than before," Raines said.

He didn't sound annoyed or bitter, just mildly surprised. Over the three decades since the hellish water balloon pushed north by Hurricane Camille exploded over Nelson County, Raines has told his story to *The News & Advance*, the *Charlottesville Daily Progress*, the *Virginian Pilot* in Norfolk and several television stations. It still dredges up painful emotions, yet he keeps telling it.

The night of August 19–20, 1969, started on the front porch of his parents' house in Massie's Mill.

"We used to sit out there a lot," he said. "It was just the cool thing to do. We were right on [Virginia] 56, and it was neat to sit out there and watch the cars go by. This particular night it was raining, but nothing out of the ordinary."

Eventually, Raines and his family (his father, mother, two brothers and two sisters) went to bed. Around two a.m., someone called. Carl Raines Sr., who sold farm supplies to area fruit growers and was president of the local

Ruritan Club, picked up the telephone next to his bed. The conversation was brief.

"My brother and I came in to see what was going on," Warren Raines recalled. "My Dad said, 'Someone called to say her car just floated away and we should get to higher ground. I don't think there's anything to it. Y'all go back to bed.'"

But Raines's mother convinced her husband to look outside.

"There was still traffic going by on 56," Raines said, "at least coming away from the mountains. We saw water on the road, though, and that was unusual. Then we realized that water was seeping in underneath the front door."

They moved some furniture up to the second floor, walked outside into the steady rain, and piled into Carl Raines's 1968 Chevrolet station wagon. The neighbors behind them, a couple named Wood, asked if their children could go along.

"So there we were, eleven of us in the car," Raines said, "and when my Dad tried to drive away, the engine cut out. Water had got into it and killed it."

By then, he said, the chilly, pulsating flow was halfway up his fourteen-year-old calves. Nevertheless, he and his family and the neighbor kids began walking up 56. They didn't get far.

"It was unbelievable how fast that water came up," Raines said. "It wasn't like a tidal wave, just a real quick rise. In two or three minutes, it was waist deep. Then it was over our heads. Then it was taking us away."

The Tye River, the neighborhood stream they had grown up with and played in, had turned into something fierce that seized them and shook them.

Borne quickly toward the James River several miles away, Raines snatched desperately at anything that might slow him down—vines, bushes—and finally managed to wrap himself around a small tree.

"Lightning was flashing constantly," he said, "and I could see my mother and my oldest sister holding on to another tree. They looked like they had a pretty good grip, and I felt my tree breaking up, so I hollered, 'If I let go, can y'all catch me?' They were maybe thirty feet away. When I got there, they were gone."

Raines eventually spent the night clinging to an uprooted weeping willow.

"It was a long night," he said. "At that point, I wasn't so much worried about drowning as I was about getting killed by some of the debris that was coming down. I saw houses, automobiles, telephone poles, cattle. One house just missed me, and I recognized it as being from up the road."

When daylight finally seeped through the angry cloud cover, Raines heard a voice calling his name.

It was his older brother, Carl Jr., attached to a nearby tree. Soon afterward, a johnboat came along and took them to shore, then to a nearby house.

"They told us to get some sleep," Raines said, "but we couldn't. We had to go out looking for the rest of our family."

Not far away, they saw their father's store deposited in the middle of the bridge into Massie's Mill, effectively blocking the main road.

"It was so unreal," said Raines. "I actually opened the front door and walked in, calling for my folks. They weren't there."

Eventually, the bodies of the Raines family were all recovered—the last one, seven-year-old Ginger. One of the Wood children was never found. Over one hundred people died in Nelson that night.

Suddenly, Warren and Carl Jr. were orphans. Their father's boss took them in for awhile, and Warren wound up at Staunton Military Institute for the fall term.

In a cruel irony, the Raines house had survived the flood.

"Had we just stayed put on the second floor, we'd have made it," Raines said.

He talks with pride about how he built up his TV repair business on the ruins of his former life. But he hasn't left the Flood of 1969 behind him.

"Things remind me every so often," he said, "like if it's a summer night and I hear a helicopter."

He also remembers the weather forecast for August 20, 1969.

"They said 'forty percent chance of rain.'"

Originally published August 21, 1999.

Two wars, two stones

Memorial Day is an insider's holiday. If you talk about "celebrating" it, then it hasn't touched you.

And that's OK with Totsie Emmerson. She can see that Memorial Day has been diluted by every passing year of relative peace, becoming just a pleasant three-day weekend associated more with casualties on the highway than casualties on the battlefield. So be it. She can take care of her own mourning.

For Emmerson, Memorial Day is not a day to get out of town. That day, she has work to do.

"It's no big deal," the Madison Heights woman said last week. "I get out the flags, hang them out, set out flowers on the graves. The only time it really bothers me is when I see the ceremonies on TV and they play taps. That gets to me. I get tears in my eyes."

Ask Totsie Emmerson about war. She's an expert, even though she's never carried a rifle.

I learned about her in a roundabout way, from a photograph sent by Lita Garra of Lynchburg. The color snapshot showed two adjoining tombstones in Spring Hill Cemetery. A note explained: "This made an impression on me, the father who died in World War II without ever knowing his son, who died in Vietnam twenty-two years later. Both were killed in action.

"With Memorial Day approaching, perhaps you could use this for a reflection."

The tombstones were adorned with small American flags, not far from Spring Hill's outer brick wall. One stone, the older one with the gray water stains, was for "Pfc. Calvert Johnson. Born April 3, 1919, killed in action,

France, December 1, 1944." The other read "Sgt. Calvert J. Johnson, Jr. born April 17, 1944. Killed in action, Vietnam, November 8, 1966. Gone to meet his earthly and heavenly father. Happy reunion."

I found a file in our library labeled "Johnson, Calvert (Jimmy). Killed in Vietnam." Inside was a photograph of Totsie Emmerson receiving her son's Silver Star and Purple Heart from a man with a chest full of medals and a crewcut. She had weary circles under her eyes, and the eyes were sad, and she was looking past the man with the crew cut as if he wasn't there.

Ask Totsie Emmerson about heroism.

"You know why Jimmy—that's what I called my son, Jimmy—was in Vietnam?" she asked when I called her. "He had gotten himself in the National Guard, but they had a rule that if you missed three meetings you were drafted. And Jimmy missed three meetings, so off he went."

Once in Vietnam, Jimmy Johnson wrote his mother: "This sergeant told me I wasn't supposed to be over here because of my father. He said all you would have to do is to go to the Red Cross and tell them you want me back in the States. If they send me home, they will turn around and send me to Germany for three years."

Later, he wrote, "War is hell. Mama, don't you or Derrell (his stepfather) vote for Johnson. The war is nothing. I can't see what we're gaining. We will go out in the jungle and stay and fight and gain nothing but more killed."

"Tell everybody hello for me. We are going back into the jungle. So if you don't hear from me, you will know why. I told them if I got shot to let you know."

Three days later, he was dead.

Johnson didn't want to be in Vietnam. He didn't know what he was fighting for. Yet when his company was attacked by the Viet Cong in a place called Tay Ninh Province, Emmerson's son "unhesitatingly moved from position to position, directing the fire of his men and offering them words of encouragement. With complete disregard for his own personal safety, he maintained an exposed position from which he could effectively deploy his men. Sergeant Johnson repelled numerous assaults before he was mortally wounded."

That information came from the Silver Star citation. The Reverend Jerry Falwell performed the funeral.

By contrast, Emmerson never knew if her first husband had been a hero or not. It took seventeen days to find out he had been killed and four years to get his body home. By then, only bones remained of Calvert Johnson Sr. Emmerson retrieved his false teeth from the casket and saved them.

"All they ever told me," she recalled, "was that he had been shot in the chest and the knee."

Calvert Johnson Sr. had been shipped overseas a week after his son was born. On his last trip home, while getting his last Lynchburg haircut, he told his barber, "Mr. Moore, I don't believe I'll be seeing you any more."

Having lived through it all, Totsie Emmerson is neither a staunch patriot nor a pacifist. Her religious faith has been strengthened, and she believes things happen for a reason. But she still wonders why she was given that little corner of Spring Hill Cemetery to tend on a certain Monday in May.

"It doesn't make any sense," Emmerson said. "My husband's twin brother fought through all four years of World War II and never got a scratch. And he didn't have a family."

Maybe Calvert Johnson Sr. and Calvert Johnson Jr. discussed that at their reunion.

Originally published May 29, 1989.

Earl Hamner

The first writing Earl Hamner ever did for public consumption was a poem about his dog. He was six at the time.

"The thing was," his mother Doris once recalled, "he didn't have a dog. But after reading the poem, his dad went out and got him one."

This may well have foreshadowed young Earl's destiny. Through his life, the courtly Nelson County native has been able to spin reality out of imagination—or, in the case of the now-classic, Emmy-winning TV series *The Waltons*, reality from reality.

"A lot of folks seem to have trouble telling the television show from real life," Hamner once said. "It's funny sometimes."

But not surprising. John-Boy Walton, played for all those years by Richard Thomas, is actually Earl Hamner's inner child—literally. John-Boy grew up in a very large (there were eight Hamner kids), close-knit family in the foothills of the Blue Ridge and the bowels of the Great Depression. He became the first of his family to go to college and eventually found work as a writer.

What makes Earl Hamner special is not that he left Nelson County to become successful, but that he keeps coming back.

"He's never lost his feel or his love for the area," says Lynchburg College communications professor Woody Greenberg, a former member of the Nelson County Board of Supervisors and a longtime friend of Hamner's. "He tries to visit at least two or three times a year."

Hamner grew up in Schuyler, a tiny community that used to be known for its soapstone quarry. Now, it's known as the epicenter of the *Waltons* phenomenon.

"In 1973, when the show had been on for around a year," Greenberg recalled, "Earl came back from Hollywood for a Nelson County Day celebration. Word got out and a thousand people showed up, most of whom claimed to have gone to school with Earl in Schuyler."

"We thought we lived in the best of times," Hamner, who also wrote for the series *Falconhurst*, told the group. "Many years later, I learned that we had been 'economically deprived,' that we lived in a 'depressed area,' and that we suffered from a disease called 'familism.'"

"The sociologists define 'familism' as a type of social organization in which the family is considered more important than either other social groups or the individual. Not knowing that we were afflicted with 'familism,' we just thought we loved each other."

Hamner finally left his warm Nelson County womb to attend the University of Virginia (as did John-Boy), then served in World War II. He paid his writing dues producing scripts in Cincinnati and New York, finally breaking through by selling an idea to Rod Serling of *The Twilight Zone*.

Meanwhile, his first novel, *Spencer's Mountain*, was published, sold well and became a movie starring Henry Fonda. It was America's first glimpse of the family that later would be invited into millions of livingrooms and dens.

Yet *The Waltons* began not as a series, but as a one-shot Christmas special titled: *The Homecoming: A Christmas Story*. That aired on CBS in December of 1971, and triggered an avalanche of favorable mail that convinced network chairman William Paley to expand the concept into a series.

"We've been taking out of the well for too long," Paley said. "It's time we put something back."

The Waltons began its run on September 14, 1972, and continued until August 20, 1981, when it died a natural TV death after surviving far longer than most TV series. It lives on in syndication, and more importantly for Nelson County, inside the Walton's Mountain Museum at the former Schuyler Elementary School.

"It was a real blow to the community when the school was closed," Woody Greenberg said, "because that building was the heart of Schuyler. Then there was Earl and all the interest in *The Waltons* show, and it just seemed to make sense to create a museum about the program in the old school."

Hamner, whose brother James (Jim-Bob in the show) still lives across the street from the school, latched onto the idea enthusiastically. He used his influence with the Lorimar production company to get its permission and help gather memorabilia, while Greenberg rallied

community support. More than four thousand people showed up for the museum opening on October 24, 1992.

"What this gave Nelson Countians was something to feel proud about," Greenberg said. "There was nothing negative about that program, unless you were a city slicker who just laughed at the values it espoused."

Woody Greenberg came to Nelson in the 1970s from New York City. But he wasn't laughing.

Originally published November 28, 1999.

The Misses Ward

When Floyd Ward talks, people listen. And when they reply, they generally say: "Yes, Ma'am."

Obviously, this authority stems from something beyond the physical. Despite her diminutive stature and soft voice, Miss Ward projects the inner steel of a Golda Meier. And of all the young people who have passed—joyously or reluctantly—through the portals of her dancing schools, few have crossed her.

"Floyd Ward was a dancing teacher in the true sense," said Jewel Price Arrington of Troutville, who attended the Floyd Ward School in Dancing in Roanoke. "There was no nonsense in her class. No one chewed gum, or talked back, or failed to report front and center when she said so. An ear-piercing whistle reminded you that she meant business."

More than sixty-five years after her first dancing lesson (from Florence Barr in Lynchburg), Floyd Ward continues to disseminate culture with the zeal of a Johnny Appleseed.

"I've had to slow down some because of my shoulder," she admitted recently, "but I'm hoping it won't keep me down for long."

The aches and pain of old age? Not really. Although she is approaching eighty, Miss Ward injured her shoulder while ice skating. She also has a state-of-the-art plastic hip joint (the original fell prey to arthritis) that does not deter her from springing to her feet in the midst of a conversation to demonstrate a pertinent point about dancing.

Dancing.

"Please don't say 'dance,'" she gently corrected a recent visitor. "It's 'dancing.' You might as well say 'write' instead of 'writing.'"

"Now, Floyd," said her younger sister Virginia from across the living room of their Rivermont Avenue home. "A lot of people say 'dance' these days."

"I don't care," replied Floyd firmly. "It's 'dancing.'"

Virginia generally maintains a low profile, deferring to Floyd in most conversations about the family business. She greeted the arrival of rock n' roll with amused detachment, while her sister regarded it much as the Romanovs viewed the rise of the Bolsheviks.

"The twist," said Floyd, gritting her teeth, "was the beginning of the end."

By way of mourning, she once startled one of her classes by appearing in a gorilla suit, thus demonstrating her belief that popular culture had reverted to the primitive.

Yet it would be grossly unfair to think of Floyd Ward as a dinosaur. She didn't dislike rock n' roll because it was new—she just disliked it. And her gorilla suit was a satirical stroke that cut both ways.

"I was once invited to a party where we were supposed to dress up like our ancestors," said Miss Ward, who is descended from the original Lynches but hates to dwell on it. "So I wore my gorilla suit."

In many ways, the Ward sisters have adapted smoothly to changing times. They include modern dance—er, dancing—in their curriculum, and Floyd seized upon the short-lived disco craze as a life preserver in a sea of incoherent rhythms.

"They called it 'touch dancing,'" she said recently. "How ridiculous. People have been touch dancing for decades."

"But at least it was better than that other stuff."

The Wards reserve a special affection, however, for ballet. Virginia has visited France, England and the Soviet Union to observe European teaching methods. Floyd once studied with Veronine Vestoff, a ballet master who had been personally recommended by the great ballerina Pavlova.

"When I was in high school, Pavlova came to Lynchburg to dance at the Academy of Music," recalled Miss Ward, who by that time was already teaching clandestine classes of children on her back porch. "I wasn't impressed—I didn't know who she was. But after her performance, I met her backstage and asked who she thought were the best ballet teachers in the country. Vestoff was one of the ones she mentioned."

So Miss Ward went to New York, which didn't impress her, either.

"The only thing I've ever seen in my life that really impressed me," she said, "was the Grand Canyon."

Vestoff invited her to remain as a personal pupil, she recalled. And she still keeps a yellowing letter from him, dated September 23, 1926, that says in part: "I regret that you find yourself unable to accept a position in my school as you have natural genius for teaching, as well as being an artiste in the dance."

But New York was "big, dirty and noisy," and Lynchburg was home. That's why she was "unable to accept."

The Wards don't encourage today's students to dance professionally. They do encourage manners. Their younger ballroom dancing classes still include the time-honored receiving line and the Grand March. Young men are taught how to open car doors for their dates, ask for a dance and serve punch with white gloves—skills somewhat irrelevant, perhaps, in the laid-back 1980s, but still considered important by the Misses Ward.

"I realize that none of these children are likely to be wearing white gloves in a receiving line," Floyd said, "but how can it hurt to teach them? At the least, they'll learn a little consideration for other people."

It's hard to think of Floyd Ward as a women's libber, but that's exactly what she was when she started out in the early 1940s.

"When I started my dancing school," she said, "my father said, 'No daughter of mine is going to work for a living.'"

As might be expected, he eventually backed down. And Floyd and Virginia bought the old Masonic building at the corner of 11th and Church streets for their classes.

They're still there.

Originally published September 19, 1982.

Liberty University

The modest elevation known as Candler's Mountain has not only overlooked a lot of Lynchburg history, but hosted some of it.

John Lynch owned land there, and U.S. Senator Carter Glass lived there. But the Reverand Jerry Falwell went a step further—he tried to reinvent the mountain entirely.

On January 21, 1977, Falwell and more than 25,00 Liberty Baptist College students and faculty members gathered on the mountain for a prayer meeting. Eight inches of snow lay on the ground, and the temperature was below freezing. For Falwell, it was a grand theater.

The assembled group sang "I Want This Mountain," and claimed the mountain "by faith." In a burst of practicality, they prayed that God would enable them to "eliminate all unsecured indebtedness by February 28, 1977."

More than $2.5 million in donations flowed in the rest of that month alone, and before long bulldozers were rooting in the flanks of the mountain variously called Candlers, Montview (Carter Glass's farm) and now—at least among the Thomas Road Baptist Church faithful—Liberty. The school opened on schedule.

Still, the road up to the mountain had been long, winding and full of potholes.

Falwell started his church in the abandoned Donald Duck Bottling Company on Thomas Road in 1956. Before long, he had his own radio show. He sent buses around city neighborhoods to recruit kids for Sunday School. Then, in 1967, *The News* reported, "A non-profit, non-stock Lynchburg organization has announced plans to build a private school for white students on land in the Evergreen Farms area. There will be

facilities for all elementary and high school grades when the buildings are completed."

"I was raised here in the South," Falwell later said in disavowing his early segregationist tendencies. "My father was a strong segregationist—everybody I knew was. You just assumed that segregation was ordained in heaven."

The school took shape as Lynchburg Christian Academy, and a noted Christian educator named Pierre Guillermin (later the president of Falwell's college) came from Orangeburg, South Carolina to take charge of it. But the engine that drives Jerry Falwell never stops running, and one January day in 1971, he stood behind his pulpit one Sunday morning and announced that his ministry needed a college. He used a verse from Timothy ("Commit thou to faithful men, who will be able to teach others, also") as his rallying point.

Seven months later, Lynchburg Baptist College was born, although its origins were hardly of Biblical proportions. The school began with 154 students, shoehorned into two classroom buildings (actually old houses) across from the church, housed wherever the administration could find space.

"I remember arriving at Thomas Road Baptist and asking where the dormitory was," recalled 1975 graduate Steve Vandergriff. "I was led across the street to a little house. When I asked where my room was, a carpenter who was fixing a hole in the wall told me to pick any room I'd like. He told me the beds were out on the porch. I picked out a room and set up a bed, and then began the most exciting, rewarding days of my life."

Four paid teachers and several unpaid volunteers comprised the first faculty. Besides the houses, classes were held in the church and the LCA buildings. Falwell suited up and scrimmaged with the basketball team so they would have enough members to practice.

Officials at Lynchburg College threatened to sue Falwell over confusion between the name of his new school and theirs (it didn't help that Falwell used some photos of the Lynchburg College campus in his brochure), so the fledgling institution became Liberty Baptist College. A few years later came the prayer meeting atop snow-covered Candler's—or Liberty—Mountain.

Besides raising the money, Falwell had to get the land rezoned by the city. As former City Council member Ed Calvert remembered it, the first vote was four to three against the request.

"His [Falwell's] people got up to leave, obviously disappointed," Calvert recalled, "and then Gerry Orlicki stood up and changed his vote."

In many ways, however, LBC (later upgraded to university status and renamed Liberty University) got off to a rocky start with Lynchburgers.

The early students tended to be zealous in their evangelism, fanning out into the surrounding neighborhoods to hand out tracts and annoying more than a few local residents who prized their personal space. As the college grew, a security guard shack appeared at its entrance, projecting an image of secrecy and isolation.

These rough edges wore away in time. More than anything else, what helped form a bond between Liberty and the surrounding community was the construction of the 8,500-seat Vines Center, which Liberty promptly offered to area high schools for graduation ceremonies and athletic events.

Even then, financial potholes appeared in Falwell's glory road, including debts from a bond issue gone bad that threatened the very existence of the school in the early 1990s. But some new financial angels bailed it out, and by the time Pierre Guillerman stepped down as president in 1997, the enrollment of Liberty University was approaching two thousand.

Originally published December 21, 1999.

The Haysom murders

It was a judicial waltz set to words—music by harpsichord, lyrics by Agatha Christie.

Borrow the darkest *Dynasty* plot you can imagine, lend it to *Masterpiece Theater*, and you have the opening day of Elizabeth Haysom's sentencing hearing. For the first few hours, at least, the common thread was an unrelenting politeness.

The issue at hand was the murder of Haysom's parents in 1985—supposedly carried out with a butterfly knife by her boyfriend, Jens Soering—but the crime itself was barely alluded to. The grotesque details and the grisly photographs were old news now, tucked away in folders. The verdict was in, Haysom confessed to being an accessory, and it was up to the defendant's attorneys to distance her from her parents' blood.

And you knew somehow that these were not Jim Updike's kind of people. As Commonwealth's Attorney for a semi-rural area, Updike is accustomed to emotions bubbling close to the surface—the argument settled with a blunt instrument, the shotgun divorce. More often than not, the witnesses with whom he deals are nervous, flustered and cocked to explode in the direction he chooses.

Tuesday morning, by contrast, he encountered perhaps the oddest collection of character witnesses in his career—a robber-turned-counselor from the seamy side of London, a TV anchorman, a suave man-about-Charlottesville, a prison matron and Elizabeth Haysom's cultured half-brother. Not to mention Elizabeth herself.

A neatly dressed, unflappable Ivy Hill resident named Phyllis Workman typified the strangeness of it all. A distant relative of Nancy Haysom, she

talked about attending a dinner party that included Nancy and her husband Derek, Elizabeth, Lynchburg juvenile court judge Dale Harris, former city councilman Al Kemper and William Sweeney, the judge who will be sentencing Elizabeth when all this is over. Small world.

Later, Workman told of visiting Haysom in the Bedford County jail, and how all Elizabeth wanted from the outside world was "some good-smelling soap, some good-smelling powder and some good-smelling shampoo."

"Everything I could say good about her [Elizabeth], I would," Workman declared in response to questioning by Haysom lawyer Hugh Jones. "She made some mistakes, some errors, but she's obviously sorry."

Updike tried to muster indignation, but had to settle for incredulity.

"Mistakes?" he said. "Errors? Is that what you call two people being butchered?"

Workman looked at him blandly.

"Well, for lack of a better word," she said. "Are you taking issue with my vocabulary?"

Workman said Haysom was "turning her life around."

Which is pretty much what Johnny Horton said. Moments after taking the stand, Horton said he was once "a hopeless case and a menace to society."

He was also incarcerated fifteen times for "robbery, armed robbery, drug offenses and some other things."

In between, he said, he was a hairdresser and construction foreman. Now, Horton works with Narcotics Anonymous in London, which is how he met Elizabeth.

"I found her very easy to talk to, very honest. I look at her and see someone who is trying."

Updike asked Horton if he was once a con man.

"That's right," he replied. "and you can't con a con man."

When Updike tried to prod him further about the crime to which Haysom pleaded guilty, Horton simply said: "I don't judge people."

Elizabeth Watson a family friend, attributed Haysom's erratic behavior to drugs. WSET-TV's Jeff Taylor, a former neighbor of the Haysoms, emerged as one of Elizabeth's confidants. Prison matron Faye Bramlett termed her a "model inmate."

Even Veryan Haysom, a lawyer from Mahone Bay, Nova Scotia and Haysom's half-brother, said "I don't want to see her languishing in jail for a period of time that does nobody any good."

Through it all, decorum and politeness prevailed.

"May I leave now?" Elizabeth Watson asked Judge Sweeney.

"Yes," he replied, "but be careful of those steps [to the witness box]. They're very bad."

Haysom was wearing a light-colored, tunic-style dress that made her look like Joan of Arc. Her face was pale and drawn. She was twenty-three, but could have been ten years older.

She first went away to boarding school at ten, she said, after two young men in her elementary school broke her front teeth because her father ran a steel mill on strike and their fathers were labor leaders.

"I think they [her parents] wanted to protect me," she added.

As it turned out, they lost her. A year in Switzerland, seven years at English schools named Riddlesworth Hall and Wycombe Abbey (where Princess Diana also attended). She wanted to come home at one point, she said, and looked into schools in Nova Scotia.

"What happened?" Hugh Jones asked.

Haysom stopped. Her face became even paler, and she seemed to be struggling for composure. If you ask Jim Updike, it was the subtle touch of a master actress. If you believe the character witnesses, it was the gasping for breath of a wounded young woman.

"My father told me that Wycombe Abbey was very prestigious," she said in her flat British accent, "and to break up my schooling would be inappropriate."

Her father "saw in me abilities I did not have," she said. "He saw me as a scientist, an engineer."

And when her teachers told Derek Haysom that his daughter was struggling in upper-level science classes, she recalled, he said, "Nonsense."

She also said her father "found it extremely embarrassing to discuss anything of a personal nature."

So she and her parents remained at a distance, separated by an ocean and a misunderstanding. According to her confession, she even killed them at a distance.

That was the ultimate alienation.

Originally published October 7, 1987.

So long, Moral Majority

And so, in the end, the Reverend Jerry Falwell's Moral Majority showed us the short and tempestuous life of a James River flood. It rose up suddenly, thrashed around for a little while, then receded, leaving little tangible evidence of its passing.

Last week at the Southern Baptist Convention in Las Vegas (yes, Las Vegas), Falwell announced that he was pulling the plug on Moral Majority. By August 31, he told a meeting of the Religious Newswriters' Association, the group's Washington office would be shut out.

On the surface, this was not all that unusual. Almost yearly, Falwell had announced Moral Majority's imminent demise—indeed, the organization had been jump-started more times than my old Pontiac.

The difference was, this time he never added "Unless you send money."

This time, apparently, Moral Majority is history.

In a way, I'm going to miss it. Our clips files are fat with Moral Majority stories, spicy with outrageous Moral Majority crusades and equally outrageous Moral Majority feedback (remember the "Oral Majority"?). Through those files passed Cal Thomas, Ron Godwin, Norman Lear and even Barry Goldwater. For a newspaper reporter, the inscription on the organization's freshly dug grave should read: "Here lies Moral Majority. It was good copy."

Few organizations in American history have carried such power to infuriate by their name alone. Inherent in the term "Moral Majority" was an unspoken "We've got all the answers, and you don't." In the public mind, it was a corollary to the Pharisees who gloat, "We've got God in our corner."

This was a barrier Falwell never quite cleared. Try as he might, he couldn't separate Moral Majority from Thomas Road Baptist Church. They remained joined at the hip, and Old Right stalwarts like the curmudgeonly Goldwater—staunchly conservative but mistrustful of zealous crusaders—turned their backs and nursed their martinis.

It was ironic watching Falwell struggling to separate church and state where Moral Majority was concerned. Back in the 1960s, he had climbed his pulpit and sternly rebuked ministers who involved themselves with the politics of the civil rights movement. Later, he called those remarks "false prophecy."

"We're not interested in whether people are drinking or not drinking, are teaching Sunday school or not going to church," Moral Majority spokesman Cal Thomas said in 1981. "We are interested in people who can run the country."

Yet time and again, those people let Moral Majority down. Lend us a few votes, they said, and we'll pay you back later. But Ronald Reagan never launched anything approaching a conservative social revolution, and George Bush has been even more of a disappointment. Moral Majority was like the bookworm who helped the cheerleader with her homework all semester, only to be turned down at Senior Prom time.

So what did the group accomplish? In his Las Vegas Moral Majority obituary, Falwell said, "What we've done is see that the religious right is informed, registered to vote and actively involved. That was our goal in the beginning, to organize and inform the religious right."

They are, indeed, organized and informed. And Jerry Falwell is now famous, a veteran of Ted Koppel, Phil Donahue and *Newsweek* covers, a pin-striped icon. In its prime, Moral Majority excited a lot of people and scared even more.

But rarely warmed them. My theory is, there's something about politics and religion together that makes most Americans fidget. They didn't like it when Jimmy Carter talked about salvation and they liked it even less when Pat Robertson began talking about foreign policy.

At one point back in 1983, Moral Majority announced it would begin "checking every city and public school library from coast to coast to determine if a conspiracy is keeping conservative books off the shelves."

Listed among the sixty-two "quality books" were *Gay is Not Good*, *Evolution: The Fossils Say No*, and *The Sweetheart of the Silent Majority*, Phyllis Schafly.

Nobody cared. Most Americans are conservative, I think, in a passive sense. Let's keep things the way they are. Don't teach our kids about sex and

complicate our lives. Just leave us alone to enjoy our VCRs and our houses in the suburbs.

How many Americans really worry about evolution versus creationism? We're here, aren't we? And who would they rather watch on TV—Phyllis Schafly or Joan Collins?

Old-fashioned conservatives tend to view the Reverend Jerry Falwell in the same way liberals view the Reverend Jesse Jackson—it's fun to watch him bash the opposition, but nobody wants to take orders from him.

I don't believe that Moral Majority elected Ronald Reagan, but I do believe that the two were inexorably linked. Still, Ronald Reagan emerged as a smiling synthesist, not a right wing avenger. And Moral Majority became as much a cause for amusement as apprehension.

While Falwell did an admirable job of keeping the main troops in line, the lunatic-fringe chapter leaders out in the hinterlands did him in, carrying on rabid campaigns against anatomically correct cookies in Maryland and storming through libraries in Alabama.

"We chose the name Moral Majority for a reason," said Ron Godwin, another former Moral Majority vice president. "We weren't after the mushy middle."

Yet it is the mushy middle that runs America at the moment, not the left or right. And Jerry Falwell is smart enough to realize it.

Falwell basks in love and thrives on hate. Both energize him. But like a toothless old dog, Moral Majority was no longer capable of inspiring either—so its owner took it out and shot it.

So long, Moral Majority. You were fun while you lasted.

Originally published June 23, 1989.

Monacan Homecoming

When Bernard Belvin was growing up in Huntington, West Virginia, he used to get in fights because some of the other kids called him an Indian.

"One night, when my Mom was putting mercurochrome on my eye," he recalled Saturday afternoon, "I asked her if I was really an Indian. She said, 'Yes, you are—but it's nothing to be proud of.'"

Contrast that story with the current experience of Monelison Middle School student Cody Bryant.

"I've tried to learn more about my Indian culture," he said, "because I want to learn who I am. Sometimes I get asked about it at school, and I think a lot of my friends are really interested."

Somewhere between Bernard Belvin's battle scars and Cody Bryant's curiosity, the Monacan Homecoming came to be. Saturday was its thirtieth anniversary, and Phyllis Hicks was asked if the crowd wandering around the sunlit grounds of St. Paul's Episcopal Mission Church may have been the biggest yet.

"I don't know—it's tough to count everybody, because they're so spread out," said Hicks, a Monacan leader and one of the co-organizers of the event. "The numbers aren't important, anway. It's the feeling. I always cry at Homecomings. They fill my heart up."

Bernard Belvin cries, too, and he doesn't look like the crying type. Stocky and affable, Belvin is a Colonel in the Texas State National Guard and a retiree from the Texas State Prison System. On Saturday, he was wearing a striped shirt of bright colors and a Disabled American Veterans cap.

"Hazel [his wife] and I can't wait to retire here," he said. "I miss the hills."

Born in Amherst but transplanted to Huntington at an early age, Belvin began being drawn back into his roots about ten years ago, driving up for his first Homecoming in 1991. Since then, he's been elected chief of the West Virginia Monacans, even though he lives in the Texas town of Conroe.

"How does that work?" I asked.

"I spend a lot of time on the telephone and the Internet," he said with a grin.

His crying would come later, just before he left the church at the foot of Bear Mountain and headed home.

"We always wade in the creek," he said, "and then we climb up that hill to the cemetery and come back down with tears in our eyes."

It is a sad story, the saga of the Amherst County Monacans. During the years of racial segregation in Virginia, they were not allowed to attend either the white school or the black school, only the six grades at the mission school. The tribe itself was dissolved by a man named Walter Plecker, head of the state Bureau of Vital Statistics, who said the Monacans weren't a "real tribe." Paper genocide, it was later called.

Only over the past decade, thanks to the efforts of Hicks, Karenne Wood and Dianne Shields, have the Monacans earned state recognition and begun to rebuild their shattered ethnic self-esteem.

"I just got back from a meeting of Indian leaders in Tampa," said Monacan chief Kenneth Branham, a mechanic by trade. "We're trying to make sure as many people as possible list themselves as 'Indian' on their census form."

Bernard Belvin will, despite what his mother once told him.

"My friends in the Guard are kidding me," he said. "They tell me, 'Belvin, you're going native on us.' But it feels so good."

Saturday, Monacans and their families came from as far away as California to stuff themselves at a buffet dinner in the church meeting room and bid on items at a charity auction to raise college scholarship money for Monacan teens (a new wrinkle conceived by Cody Bryant's father, R.G.).

Meanwhile, Heather Branham was spending part of the day in a small room on the lower level of the church, taping interviews with Homecoming visitors to be included in a "legacy" book project.

"They all said pretty much the same thing," said Branham, a young woman who is also an accomplished Indian ceremonial dancer. "They said that it was good to be home."

Originally published June 14, 1996.

About the Author

Darrell Laurant has been a reporter and columnist for the *News & Advance* in Lynchburg, Virginia, since 1977. Before that, he worked for the Charleston (South Carolina) *News & Courier* and the *West Columbia-Cayce Journal*, also in South Carolina. Over the years, he has covered everything from national political conventions to college basketball's Final Four tournament to the Miss America pageant. He has also contributed to over thirty-five magazines, and is the founder and director of The Writers' Bridge, an international freelance writers' co-operative.

Laurant has published three collections of columns prior to this one and written two other books—*Even Here*, about a series of murders in Bedford County, Virginia, and *A City Unto Itself: Lynchburg, VA in the 20th Century*.

He and his wife Gail have been married for thirty-three years and have two children (Jeremy and Cindee) and two grandchildren.

Visit us at
www.historypress.net